IMAGO MUNDI X

FLEETING INSTANTS

MARION - VALENTINE

Texts by
Manuela Binaghi and
Daniel Dobbels

5
CONTINENTS

Editorial Coordinator
Laura Maggioni

Translation from Italian
Susan Wise

Translation from French
Isabel Ollivier

Editing
Andrew Ellis

Design
Lara Gariboldi

Layout
Virginia Maccagno

Colour Separation
Galasele, Milan

Printed in September 2004
Bianca & Volta, Truccazzano (Milan), Italy

Cover
"Lamentation" (Peggy Lyman)
Choreography by Martha Graham
(Martha Graham Dance Co)
Paris, 1976

© 5 Continents Editions srl, Milan, 2004
© Marion-Valentine, for the photographs

info@5continentseditions.com

ISBN 5 Continents Editions: 88-7439-156-0

TABLE OF CONTENTS

MANUELA BINAGHI

BODIES IN DIALOGUE

For the past forty years, Marion-Valentine, a photographer in love with the dance, has photographed bodies in movement, and *Fulgurations* is the title that, she gave this book. As the saying goes, pictures say more than words, and in this sense photography, like the dance, becomes a symbol (from the Greek *symballein*, meaning "put together") joining two realities—that of the body and that of the spirit—in a bid to overcome the dichotomy that the West inherited from Platonic thought, a dichotomy aggravated by present-day society, which has made the human body itself a consumer item.

Without a precise chronology nor a hierarchy based on the fame of the protagonists her lens has immortalised, in this book Marion-Valentine goes back over some of the most important phases of twentieth-century dance, without overlooking the "romantic" flights of the classical repertory. The great ladies of American modern and contemporary dance—such as Martha Graham, Carolyn Carlson, Lucinda Childs—appear alongside the dancers of the spokesman for Afro-American "black" dance, Alvin Ailey, and another great Afro-American dancer, Bill T. Jones, exponent of a refined, transgressive aesthetic. The surreal, rather naive world of the Pilobolus and then of the Momix with their SuperMomix contrasts with the bare, geometric, emotionless choreography of Merce Cunningham, the leader of a trend that bore other prodigious fruit: the austere dance, limpid in its destructured composure of William Forsythe, another American

transferred to Europe, in Frankfurt. Several names represent the European schools: Pina Bausch's theatre-dance captured in a gradual sequence of images, the dance of the Marseille-based choreographer-philosopher Maurice Béjart, the oneiric poetics of Josef Nadj, Yugoslav but long-time resident of France, the revisiting, in a dramatic and contemporary vein, of classical ballets (*Giselle* and *Sleeping Beauty*) by the Swedish Mats Ek (son of well-known Birgitt Cullberg), the Spaniard Blanca Li, the French choreographer Christine Bastin, and the dancers of the Teatro alla Scala photographed during the soirée dedicated to a towering figure of twentieth-century music, Igor Stravinsky.

Marion-Valentine's book also presents Japanese choreography, for instance Ushio Amagatsu, and stars of international fame like Rudolf Nureyev, Sylvie Guillem, Paolo Bortoluzzi, Grazia Galante, Maia Plissetskaia, Massimo Murru, Luciana Savignano and Jorge Donn.

Rather than present a tedious line-up of big names, the selection of pictures published in this book responds to a deeper and perhaps even more ambitious inner urge: the endeavour to capture the most intimate movements of dance itself, the art which the French poet and essayist Paul Valéry (1871–1945) defines "sacred" and "venerable" because the dancer's actions are not bound to the sphere of the useful, but to that of dream, poised between instinct and reflection, rhythm and excess. In *Philosophy of the Dance*, Valéry compares the language of the body to "an overall poetics of the action of living beings".[1] Dance and poetry are expressions of a life cycle viewed as the continuous shifting from a state of negation to a state of affirmation; the ballerina's body expresses a tension between the divine and the earthbound. I also quote Valéry because in Marion-Valentine's photos you can precisely grasp this dual aspect of the dance: the striving, occasionally even dramatic, rise to a metaphysical dimension and the inevitable fall of the body, due to the law of gravity, that reflects the human being's finite dimension. The divine participates in the human in a constant play of metamorphosis, and spares these truth-seeking bodies neither grief nor suffering. In that sense, the cover of the book is significant: the dancer Peggy Lyman interprets *Lamentation* (1930), one of the most famous solos by the "prophetess" of American modern dance, Martha Graham, a rebel who—on the same level as Picasso and Stravinsky—invented a new expressive code entirely different from the sublimations of Romanticism. The body of the dancer, who is seated, is wrapped in an elastic fabric and develops two tensions: one upward, with the torso elongated toward the left, eyes uplifted, the other downward, right leg bent, heel raised and knee pushing in the opposite direction to the torso. Marion-Valentine created an exemplary depiction of this tension between opposites: she actually succeeds in expressing all the drama of a solitary "I", lacerated by intense inner suffering, and who seems to be begging heaven for help and compassion. In this image there is a sense of poise, of expectation and supplication; pain flows through the

dancer's body, it is the lament of all the sufferers of all time, Mary and Magdalene, alive and throbbing amidst us. In this photo the body expresses a new conception of dance, since it is no longer separated from the spirit, they are both alive in an organic unity. The dancer discovers a personal language to express her being, unrelated to academic codes. In that sense Graham's aesthetic embraces the vision the poet Paul Valéry expresses beautifully in the Socratic dialogue of *Dance and the Soul*, written in 1923, and where the protagonists are Eryximachos, Socrates, Phaedrus and the dancer Athikte. Socrates says: "It [life] is not the mysterious movement permeating the circumlocutions of everything that happens, constantly transforming me into myself… It is a woman dancing and who would divinely cease to be a woman if she could extend all the way up to the clouds the leap she just performed. But just as neither dreaming nor awake can we reach the infinite, she equally always becomes herself; she is no longer a feather, a bird, an idea; in short everything the flute wanted her to be, since the very ground from which she leapt recalls her and breathlessly renders her to her woman's nature and to her friend… "[2] And elsewhere: "A simple movement, and she's a goddess; and we almost gods!"[3]

This vision of the dance, poised between the abstract and the tangible, to which Valéry is deeply attached, is not to be found however in all the expressions of body language. There is an aesthetics of profane dance, extraneous to metaphysical aspirations, having strong social and political implications. In the series of photos that describe the theatre-dance of Pina Bausch, for instance the 1997 piece with the title *Le Laveur de vitres*, the concreteness of the everyday, between the ironic, awkward gestures of the female dancer and the more dramatic ones of the male dancer, the wonderful Dominique Mercy, does not leave room for an aesthetics of the absolute. The slightest spiritual aspiration is cancelled by the toil of living, the body becomes the "social" instrument to tell the bitter joys of a humanity lacerated by couples' conflicts, by the repetition of apparently futile gestures. Expressions of an aggressive, provocative dance, alien to spiritual tensions, can be seen in the photographs of the performance *Object Constant* by the Portuguese Rui Horta, leader of a contemporary trend inspired by sports. Concreteness and determination characterise the ballerinas of the Spanish choreographer Blanca Li, photographed in the piece *Nana et Lila*, as they march barefoot, with swirling skirts, proud and vigorous, like an army facing the enemy. Images related to Spanish folklore, decisively contrasting with the frontal image, where we see a row of swan women in tutus, erect and haughty, in *Swan Lake* by Vladimir Bourmeister.

Flight

Marion-Valentine, in her dancing portraits, also seized the "eternal" instant of flight, the "leap" Valéry speaks of, because anyone in love with dance cannot avoid these "fulgurations".

The need for elevation, just think of ballerinas' use of points, at its apex in Romantic ballet, where bodies tend to become incorporeal, aerial figures, runs through the entire history of the dance, but with different expressions. In modern and contemporary dance, leaps express vitality, energy, playfulness, the urge to risk.

In Marion-Valentine's book there are many photos that show these bodies extended upward, each image telling a different story: the flight of Violette Verdy radiates radiance and grace, photographed in *Giselle* beside J.-P. Bonnefous who seems to be poised in mid-air, his arms raised, his bust in torsion and legs diagonal. Jorge Donn's leap in Maurice Béjart's *Heliogabalus*, chest bare, arms raised, in diagonal splits, with the sun in the background, is like the roar of a lion on a silent night, a hymn to life. The body releases a Dionysian energy, it is Icarus's flight defying the laws of physics. Breathtaking perfection in the aerial splits of the star Sylvie Guillem, portrayed by Marion-Valentine in the ballet *La Fontaine de Bakchisarai* by the choreographer Rotislav Zakharov. The steel points split the air, the legs trace an incisive, rigorous horizontal line, and the incredulous beholder delights in the effect of a body poised in space, released from the inexorable law of gravity. Another emblematic flight, but with legs drawn in like a frog and fingers parted wide and pointing to the ground, is that of the dancer Philippe Lizon, in Béjart's *Sacre* in Brussels, in a photo of 1984. No less spectacular is the bird's flight, with the protagonist Albrecht arched

backwards from the photo taken from Mats Ek's *Giselle*, a psychoanalytic revisitation of the famous Romantic ballet, a cry before the madness of Giselle, admitted in a hospital, after being left by her loved one. These bodies in mid-air, if they assemble the most instinctive emotions of the human being (anger, rebellion, urge to escape), they also express the need to overcome its finite nature and the opportunity to rise to other dimensions. The supernatural explodes, with all its might, in the body, altering it and opening up new horizons. "The language of the body", Antonio Gentili writes, "formed by its nature and its functions, reveals the secret language of the spirit that is 'materialised' in it and expresses itself through it." Dance becomes prayer, breath of the Spirit. In the Hebrew tradition, but in oriental religions as well, the body is analysed in its multiple aspects: physical body, psychic body, spirit body. "Breath—Gentili adds—in the Scriptures is seen as the 'flame' given to man by God so he can fathom the hidden recesses of his soul (cf. Prv. 20:27)".[4] We need only think of the dance of the Indian god Shiva whose theme, as the philosopher Roger Garaudy writes in *Dancing Life*, is cosmic activity: "Our God, says a sacred hymn of India, is the dancing god who, like the heat of fire when it envelops the log, radiates its might in the spirit and in matter and sweeps them up into the dance as well."[5] The connection between dance and religion goes back to primitive times, tribal dances were dedicated to the forces of nature to propitiate their favours or give thanks; through the dance people came

in contact with nature, with society, with the future and with the gods.

Yet the leap also has a more playful, careless valence, for instance in the sequence of photos portraying the light, poised bodies, like countless molecules in mid-air, of the dancers of the New Yorker Lucinda Childs, leader of an aesthetics of pure, conceptual and minimalist movement. Marion-Valentine's photos give us that impression of flowing, continuous energy, far from any form of expression, traced by bodies skipping regularly inside a well-defined geometric pattern. With the piece dated 1979, *Dance*, the elevation is generated by Philip Glass's music and becomes an ideal counterpoint for an endless, repetitive series of leaps, without any transcendental aspiration. It is the expression of an abstract dance arisen in the United States between the two World Wars, derived from artistic trends (we refer to Marcel Duchamp, who influenced the aesthetics of one of the founders of contemporary dance, Merce Cunningham, or to Jackson Pollock's painting) and founded on the notion of energy. The body expresses life in the sense that it conveys energy. In this book, Marion-Valentine's lens catches all the energy of these bodies moving in space and time, her sensitive eye follows the revolution that occurred in contemporary dance overwhelmed by the spatial-temporal concept drawn from Einstein's theory.[6] Every point in space has an equal importance, there is no longer a central point of observation as in the tradition of classical ballet, bodies become molecules moving about in the universe.

Hands

The author of this book does not immortalise just the broader human movements, leaps, pirouettes, elevations on the points, but also those tiny, more discreet and less showy gestures that can express the deepest moods. They are the unsaid things, merely suggested by the hands grazing each other in the photo with the two Japanese dancers, a man and a woman, portrayed in Susan Buirge's choreography, *Ubushuna*, in a highly effective play of lights and shadows. These are the palms of Jorge Donn's open hands in the photograph with Luciana Savignano (*Ce que l'amour me dit*, choreography by Maurice Béjart) "offering" support, helpfulness, affection, to his companion seated on his thighs with her arms wide open. And the dancer Shonan Mirk's light little movement of the right hand in the piece titled *Fragments*, by Maurice Béjart, is more explicit than words. Hands in the art of the dance have an enormous symbolic value, from its dawn up to today; the hand is a sign that calls up something else. Maria Fux, one of the most renowned dance-therapists on the international scene, writes in her book *Fragments of Life in Dance-therapy*: "The hand, we never look at it, only when we wash it or put cream on it. We never feel 'my hand'. The hand that knows how to offer tenderness, that caresses, that is often annoyed, that works and accomplishes infinite gestures in space and in life, that feeds us, but does not weep. My hand is like the mirror of my body. We move with it, seeking in the space around us and also in our own body an encounter so as to

communicate".[7] The hand, like dance, is poetry, its gesture goes beyond the contingency of utility, it is not a mere tool for grasping or releasing, but a means that opens new, deeper and more intimate horizons.

Rhythm

Marion-Valentine's book also deserves another comment, this time on the rhythm of her images. Indeed the photographer has selected a series of sequences in which the movements are interwoven in a dialogue that verges on a new choreographic composition, and other images, instead, that by themselves evoke a world of sentiments and emotions. Once again we contemplate the sequence with Jorge Donn, the Argentine dancer, the extraordinary interpreter of countless masterpieces by the choreographer whom Marion-Valentine caught in his virulent sensuality while he dances *Heliogabalus*, *The Ninth Symphony*, and *Nijinsky*, and leaps skyward with his flowing blond mane, or else when he squats his legs and mimes oriental gestures with his arms. Marion-Valentine alternates soaring movements with other medians and this alternation provides the bodies already in action with even further movement. The dancer is like a musician alternating "low" and "high" sounds. The Hungarian Rudolf von Laban, one of the leading theoreticians of the dance in the period between 1920 and 1930, the inventor of Kinetography, the notation method for danced movements, saw in the dance the expression of physical, but also mystical, impulses. For Laban the dancer

must express three dimensions of his Self: physical, psychic, and spiritual. "The dance for Laban is the expression of the striving to overcome ordinary nature; it is the invasion of the supernatural in Man", Roger Garaudy writes in *Dancing Life*.[8] But what does all this have to do with rhythm? For Laban work and dance are both rhythmic efforts, both achieve movements that do not just seek to reproduce everyday life, but a higher life. Often the repetitiveness of certain gestures while we are working produces rhythms, songs and dances. Without delving into the classification of movements Laban drew up, it is important to underscore this rituality of gestures that become rhythm within a universal vision of the course of humankind. After all, even in the sequences of portraits by Marion-Valentine, we precisely grasp the notion of rhythm tending toward new horizons. Bodies stretched upward, others bent toward the ground, some taken while diagonally twisting the torso in a vast range of positions that involve gazes, hand signals, reluctant escapes, dramatic supplications by criss-crossings of arms, positions as innumerable as the expressions of the human soul. And in this succession of positions and rhythms Marion-Valentine experiences her passion for the art of movement, in an amazing unceasing trajectory that catches every suggestion of life in becoming. The movement of life, the ineluctable path toward the unknown to which we are all called, is dance becoming image. While it is true that photography tends to freeze movement, this is not true of

these sequences since they transform themselves, on their own, in a language in becoming that has nothing to do with any kind of immobility. The cocky gait of Maia Plisetskaia in the role of Isadora Duncan, the pioneer of free dance, shown after dancing the Béjart choreography *Isadora*, ends this book in a carefree mood. With her flowing hair and long rippling robe, Plisetskaia looks like a Botticelli figure, evocative of Spring, youth and the love of life. Her light, free and easy step is a hymn to joy and to love. Valéry writes in *Soul and the Dance*: "Only the dancer can make the essence of love visible with her gestures of beauty. Everything, Socrates, everything in her was love!"[9]

We are grateful to Marion-Valentine because with her photos she has opened a path of understanding of love, through the dance, a language highly contaminated today by the other arts, but whose symbolic value is intact. This book is a journey in the world with its contradictions and its deepest aspirations, it does not shy from pain but gives us the opportunity to contemplate the beauty these moving bodies communicate.

1. Cf. VALÉRY, P., *Philosophie de la danse*, in *Oeuvres complètes* (Bibliothèque de la Pléiade, Paris: Gallimard, 1957), I, p. 1402.
2. Cf. Idem, *L'anima e la danza* (Milan: Arnoldo Mondadori, 1947), p. 37 (Idem, "L'âme et la danse", in *Oeuvres complètes* (Bibliothèque de la Pléiade, Paris: Gallimard, 1957) II, p. 151.
3. Ivi, p. 44 (in French: Ivi, p. 156).
4. Cf. GENTILI, A., *Le ragioni del corpo: i centri di energia vitale nell'esperienza cristiana*; Ancora, *Dentro il mistero*, 4, Milan 1996, p. 6.
5. Cf. GARAUDY, R., *Danzare la vita* (Assisi: Cittadella, 1973), p. 13.
6. GUATTERINI, M., "Merce Cunningham. La svolta postmoderna", in *La danza moderna. I fondatori. Seminario I*, Comune di Rovereto, Festival Internazionale Oriente Occidente (Milan: Skira, 1998), pp. 51–53.
7. FUX, M., *Frammenti di vita nella danzaterapia* (Pisa: Edizioni Del Cerro, 1999), p. 136.
8. GARAUDY, R., *Danzare*, op. cit., p. 114.
9. VALÉRY, P., *L'anima e la danza*, op. cit., p. 54.

Bibliography

BENTIVOGLIO, L., *La danza contemporanea* (Milan: Longanesi, 1985).
KOEGLER, H., *Dizionario Gremese della danza e del balletto*, Italian edition edited by Alberto Testa (Rome: Gremese, 1995).
RAFTIS, A., *Danse et poésie: anthologie internationale de poèmes sur la danse* (Paris: La Recherche en Danse, 1989).
SASPORTES, J., *Pensare la danza: da Mallarmé a Cocteau* (Bologna: Il Mulino, 1989).
TESTA, A., *Storia della danza e del balletto* (Rome: Gremese, 1988).
VACCARINO, E., *Altre scene, altre danze: vent'anni di balletto cotemporaneo* (Turin: Einaudi, 1991).

DANIEL DOBBELS

ECHO CRIES NO MORE

"I dream of those inexpressible encounters that take place in the soul, between different times, between the paleness and the passes of those rhythmic limbs…"

(Paul Valéry, *L'Âme et la Danse,* p. 154)

The soul does not just pass by, it invents its passage, the path it takes and the body itself, through which it silently craves grace, without breaking the silence, resting and dancing along the thread of that silence. This body (the dancing body) watches the silence, it is born of silence and keeps watch over the terribly profound silences that lurk beyond what we see or imagine. This body imagines nothing. It consents, in its own light (under its own aegis), to give a glimpse of one or several images of its strange course, to which no one has the key except, perhaps, the obscure object of choreography. It lets itself be visited, turned into a spectre, seized by an instant of visibility which is only partly its own. It is the instant that photography—an art obeying another time, so tardy that it seems linked to imminence and urgency—lights up, but in a night that it does not dispel. This night has a mineral gleam that is picked up by the body alone. Neither earth nor stone nor rarefied air suspects its echoes, its waves, its endless radiance. Marion-Valentine's photographs capture those pinpoints of light, safe from the backlash of time.

Pinpoints of light which make a game of all styles and genres, and the borderlines between what is ancient or modern, out-of-date or contemporary, a movement that is living or dead. Here, such divisions have, in a sense, no grounds for being (which does not mean that they are irrelevant or invalid). But, even if only for a time, we must arrest their legitimacy and their power to intimidate. We must see something else, something more sustained and compartmental, something intermittent and freed of the forms which give body to this gleam of light. A dance, here, seems to have returned from afar and wards off the threat of a blind and deaf dispersion. It echoes an ancestral desire for justice which urges us to pay more attention Echo's body than to that of Narcissus. It is from her rocky wall, from her muteness and walled silence that the body, dreaming of being born again "between times", detaches itself almost imperceptibly, with such intensity that it becomes almost numb, so that the space will at last provide what Echo has being *waiting for.* A detachment which would be imperceptible to us had the photograph not recorded it, translating its turn or leap (whether sideways or in the air, or struck by the demands ofthe ground). It is a matter of leaping free… free of a curse or a paralysing stillness. A vigorous twist. Around an axis of unprecedented calm.

This long awaited moment (which is part of dance but not a special part) is tangible in this photograph of Carolyn Carlson which *sees* her breaking the secretly malevolent charm. Her body breaks the spell. It dances, shattering its shape and the force which condemned it, for no apparent reason, to indistinctness. It draws its own mandorla. It stretches and curves, angles and opens an alveolus of movements that were previously forbidden. It breaks free and reveals the plasticity of instantaneous movements that cannot be at variance with one another. This body holds the trace of a timeless gleam along its hip, at last becoming ephemeral. The gleam will vanish but the body will live on. The body is made of hard stuff and will endure. An indescribable moment, fascinating, spellbinding. The photographer's eye catches all its facets, even the hidden ones. She suffers from no confusion or indiscretion. A dance is born whole before her eyes, with no infancy, no cry, no help. It is its own midwife, its own weight and stretching, its own breath and virtual trajectory. It cherishes no illusions, it pierces them—and the photograph fully understands that reality. A photograph that is not fascinated by the image.

An unexploded mine stirs and travels implacably through *L'Or des fous,* underneath the scenography. The real ore of the movement, indifferent to the effects of staging and to the choreographer's imagination, filtering her intentions so as better to celebrate this endlessly repeated act of birth: dance bringing a body out of stone. Delivering it. A

strange birth that the photograph watches from afar, not seeking to offer another world to receive it. Marion-Valentine's photographs lie between two worlds.

A crazy, reverse birth. Brigitte Asselineau in *Le Silence des sirènes* seems to be born backwards, against the flow. Thrusting against the current into a future that the legs have no conception of. A naked moment in which birth is not an *act*. The birth of a movement cannot be pinned down, certified, fixed in time.

What the dancer knows and secretly feels (but she does not wish to talk about it), what the choreographer calls forth but dares not believe, the photographer fearlessly distinguishes. Silence could have concealed and buried what had no grounds for being, but, in a single shot, the photograph measures its full impact, at once unspeakable and indirect. A naked photograph for a naked body. A twofold event. Dance gives birth to a state of being that will not be violated (the dance will see to that); a witness shows the amplitude of the event without unveiling it.

A double presence, a double present—seen from two different angles.

"The instant characterises the present as having no past and no future. Therein lies the imperfection of the life of the senses. The eternal also characterizes the present as having no past and no future and that is the perfection of the eternal" (Kierkegaard). The photographer and the dancer ensure that this gap in time is maintained in its entirety, like the time of a promise just out of sight, the moment when the eye skims over the skin but cannot turn it inside out.

The attraction of this time gap, which the body can sustain alone in the unique moment of the performance (but the eternal present, so real in the sensation of dancing, later dissolves into a blank memory), must be doubled by a second medium with its own laws, its own method of composition. The photograph gives a fragment of what the body of Betty Jones, in *There Is a Time*, pulls from the collapsing space before her, holding up a sheet of invisible movement. A fragment of eternity in this "perfect" instant. Because it is seen from two different angles. A live angle and a dead angle, the first vivifying the movement, the second deadening it. Between the two, the body seizes what is blind in any movement (knowing where it is going, the dancing body is receptive to the double lucidity of the present), fingers its texture, the nap and the threads, while the photograph, rather than framing it, cards the stuff of time, which it lifts and plucks from the air or unreels.

Dance is not a matter of vision but lucidity: the photograph seizes the desire for a vision which tends towards that lucidity. The photograph offers an ex-traction of what the dancing body reveals almost beyond itself: a pulsing vein attaining another light, a silvery light, a silver image.

Lines and Layers

Lamentation—an essential solo. Beyond all horizons. Danced over a bar across the belly, sawing the body in half, bending it in a place where maimed, extinguished forces lay siege to a body that must answer for its outrageousness. Striped, black veins drawing the staccato lines of breath. Martha Graham hinted that dance distils the body's venom and brings out its power, as fine and sharp as a line, or a wave, or the edge of a lagoon. The body is there, clinging to its own powers like seaweed, like an octopus trying to slide out of itself to sprawl on this virgin beach that could be a space for dancing. A still distant edge, snapped by Marion-Valentine's photograph like sheer geometry, so cleanly and directly drawn that it has the elegance of a line—the line which is precisely what the body is waiting for.

For *Lamentation* is a dance which tries to draw a line, to mark and move a border that dance had hitherto not suspected or, since Mary Wigman, had just glimpsed or sensed. It is the event of a body which finds the slits and holes in the hampering shroud, making the stem of a dance rise out of this clinging, stretchy fabric.

A stem of a boat sailing towards that unimpeded space which is perhaps the only space we can bear to stare at without faltering, there where contact is made with "space as an infallible partner" (Graham).

The terrible infallibility of space! Coming so close to the body from so far away! What strength the body needs to greet it, to endure and translate into the language of dance the heaviness of space, its slicing movements and dazzling lights, its intensity, its sticky masks and sudden ripping away, its collapses and arid solidity! *Lamentation* is an exorcism, a way of warding off anguish.

This photograph shows the unfolding of anguish: it seizes its secret shadows, the inner folds where the lines of dull light prod and pluck at the dense, dark masses. Imploration, incantation, crazy obstinacy, carried on a polar rhythm, are the moments that the dance scarcely retains, seeking another pass, another passage. Nuptials with the infallible partner: shadows espousing the effects of a nameless light, which are also the outer walls of a naked space—too lightweight, too weighty, too sudden or too playful, but intensely desirable.

This "too" answers the anguish. It chisels, cherishes, veins and engraves it with the diamond that is the body itself. An unflagging, solitary labour, a struggle, seeking a way out of this "immaterial grip with its contradictory movements", that Henri Michaux speaks of in *Connaissance par les gouffres* (p. 13). That is what the photograph lets us see, with its own way of detemporalising time: this body extirpating itself from an abstract grip. It is the second view needed for us to see it. For us to understand how dance does not telescope reality.

A contact print, fixing the alliance, protecting it and carrying it beyond the antinomies to come, throbbing pulses or incomparable fusions. The presence of a third party—filtering for our eyes the

embrace which gives birth to a different space: other than that of the body itself, other than that of the infallible partner—that of this *unprecedented* dance. Fracturing the logical, calculable continuity which a particular history of dance would have like to be (its classes, hands on the barre, its disciplinary approach, excluding all eddies and undertows, all nausea, all waves).

A body with an exclusive grace, exempting itself from the powers of mass and its swells, gathering to itself a brilliance that the single "subject" makes shine to the very verge of decline. Whether classical or romantic, that body bears the wrinkles of its destiny before it. Graham's body effaces them like proof of its advance towards the unknown body which, in time, will retranslate the traits of its indestructible memory (the passage at arms of a disarmed soul).

Body and soul between two dancers:
Martha Graham and Peggy Lyman

The dread of time is transported. Legible in this photograph in which the dance demagnetises the conjunctive attraction of the fabric, drains it of all its meanings to the point of revealing a face exposed to the mutest of all questions, which rises from the most contrary and thwarted movements. Movements sustained as such, limb to limb, revealing this epiphany in which dance deals with its past… With past time so that a single time does not ultimately overcome a body

seeking to convey a rarer image of it—an image never seen before, which will show that the body can die and be reincarnated without duplicating itself in too pure and simple a way.

A necessary mask has vanished, time has gone by: here it is no longer Martha Graham's bony face which appears, emaciated by her mortal demand that nothing be conceded to death; no, it is the full face of Peggy Lyman, which seems visited by a second presence, charged with taking still further, and closer to us, the meaning of a dance which turns back towards a life snatched from immobility, sensing the future as the truth of its movement. This mask—Graham's own face, combining in a single dance all her ages, her gravity, youthful ecstasies, extraordinary slumbers, unbeatable lucidity—is that of impassibility. More than immobility, impassibility gives rise to a dance made up of sudden trances (trances by essence, sudden and fleeting), trances that Barbara Morgan's photography filters, as if, going beyond the revealing contrast of negative and positive, a bodily state has come back to dwell in it, inventing its own spectre, that is, its own light. The intensity of this moment is doubled: Peggy Lyman inherits it; Marion-Valentine receives and interprets another part of the heritage.

A singular moment in the history of dance and in the history of photography. An event occurs, unpredictable both times.

Twice in a single time scale split over several years. The handing on of a stock dance gives rise to a double viewpoint with the greatest

delicacy. A very strange book could be written there, half open on visions folded like a filter distilling pure movements—pure as venom, as Martha Graham would say. A poisonous dance, a venomous chemical, a secret laboratory in which each drop leads to a double revelation, an ageless revealing power. Improbable memory, *unprecedented* in its loyalty, in which the bodies follow their indestructible path, linked to "that infallible partner that space always is", according to Martha Graham. These fragments of light—the photographs—testify to it: "Mosaics, as arbitrarily fractured into minute fragments as they are, lose none of their majesty… The separate, disparate pieces are assembled to make a whole; nothing could give a more powerful idea of this transcendence, whether what emerges is a holy image or the truth. The harder it is to measure them directly against the basic concept, the more decisive is the value of the fragments of thought, and on it depends the brilliance of the presentation, just as that of the mosaic depends on the quality of the glaze" (Walter Benjamin, *Origine du drame baroque allemand,* p. 25).

The mosaic of a dance that is itself spangled with mortal features, sudden distortions, unlikely resurrections, dry masks incrusted in the skin, imperceptible ageing, sudden surges and sharp pains, like smothered anger, intoxicated with the separation from the past, is reassembled here, between these two photographs. Distilled incarnations of a dance slipping along the narrow passageway of time. Stage make-up in which the dance shimmers in the magic of greys and blacks.

A strange book (only two pages here) like a book of spells that the bodies and images will fill out, leaf to leaf, beyond the power of language half-stunned by such an operation. "The free stage, filled with wild imaginings, exhaled by the sweep of a veil with attitudes and gestures, becomes the very pure result" (Mallarmé, *Autre étude de danse,* p. 309). A stage free of any scene (just space at last), veiling its brilliant flashes, seeing them multiplied in the watchful eye of the photograph, where it is indeed the truth of the dance which is to be prolonged as if by exhalation, the subtle play of exaltation. Fulgurations—white corollas, black skins, a body concealed like a gem. The photograph exorcises its negative aspect. It frames and imports. It has the virtue of pollen.

What is photography seeking to record? Of what arrested shock wave does it claim to be the "signity", a sign warding off a flood of indignity? Or the arch witness, bringing unstable proof of movement on the verge of being ruined by emotion? The danger, always lurking there, of stepping out of line, tumbling over where even a leap would no longer be any use, but would founder, cut off from or drowned in its own revolt, losing forever the power to rebound.

A leap that contemporary dance has such trouble reintegrating. Contemporary dance that had to earn and invent a ground which

does not depend on the earth or the sky or on any existing element. A nocturnal step, foreign to day and to night, which rises ever so slightly, traversing every possible emotion. It is this freedom indifferent to all horizons which is illuminated by the body of Linda Casper in the choreography of Elizabeth Schwartz. A step in which even balance is not unreal, but just a segment taken from a movement which lingers there quite naturally.

Motion so pure that it seems to answer, and hold at a distance, the excess that comes from too powerful an emotion. A word to be understood in the sense suggested by Lacan: "Emotion refers etymologically to movement, except that here we would help it along with Goldstein's sense of throwing out, ex, out of the line of the movement—it is movement which disintegrates, it is the reaction that we call catastrophic…" (*L'Angoisse*, "Le séminaire", Book X, p. 18).

At this point of disintegration (the very seed of emotion), Marion-Valentine's photographs lay out a space for one last inscription.

They seize the emotion before it becomes too intense, too keen or suddenly mortal. A dancer is never allowed to weep. Tears are kept close to the body. Outside the dance's spellbound space and time, they ferment; they do not hatch any desperately tragic or comic plot. Judith Jamison, in Alvin Ailey's *Cry*, intimately and secretly reveals how close they are: the barest, sparest movement is always a curve which holds tears on the verge of its line. The dancing body can go only as far as that, to the verge of tears—before they invade the "sentiment" of dance evoked by Nijinsky, before they blind the eyes and burn up any possible outlet. Sublime function.

A strictly choreographic function. In it, dance meets its net, taut and yet slack, meshed and empty in the tight game of time. *Dance* by Lucinda Childs draws and describes this constant testing: the slight elevation of the bodies, the carriage of the arms, the intimate shifts which regulate the embodiment of the structure and cloud its crystal clarity. It floats and moves, imperceptibly etamorphosing as it espouses the dynamics of a dance essentially punctuated and intermittent in its encounter with the geometrical, determinate aspects of space. An eye with a strange lens appears and metamorphoses within the pattern of the dancers. It is one-eyed, invisible, hollow like a cage, solid like a magnet. It is abstract— marvellously, rigorously abstract.

It waters the space and pries it open like an absolute eyelid; under its protection, the dance plays out its figures, distorts and stretches them, magnifies them like lenses, teases and exhausts them, the better to extract the instant from them—a sheer hypnagogic game, unforgettable and short-lived.

Le Laveur de vitres by Pina Bausch explores all the traits of the window cleaner—from twist to caricature, from joy to ligature.

What this series of photographs shows, by segments, is that dance is like double glazing: its soundproofing intensifies the bodily states seen through it.

An objective complicity with the art of photography. Making silence into a viewpoint, making a carnation or a carpet of flowers into a flowering of gestures on the verge of distraction. Dance and photography accept that the gestures are lost twice over and their alliance doubles up the traces they leave; but truly distraught gestures would be the death of both dance and photography.

For the circle would be empty. Not even broken but atrociously flat—devitalised. *Hiyomeki* by Amagatsu traces its faint slant. The bodies leaning imperceptibly towards the undulating centre, where the depths haunt the surface and fold it like a fan of time. The perfect upright of the frame holds this imperceptible dizziness.

And offers it an unsilvered plane (the very opposite of a mirror) which records and reflects the pulsing and shimmering on its black surface.

A black plane—as a background. Recurrent. Omnipresent.

It, too, is doubled or split by two genres, two types of training foreign one to the other (beyond any analogy or comparison). The "classical" genre comes out of the blackness, holds it at a distance and, with a stroke or a point, denies it (relegates it to nothing—to this hollowed stage of which it claims to be the only way out). When the act succeeds, the icon attracts and focuses all eyes on himself: Nureyev in *Apollon Musagète*. The icon annihilates space, whitens the body. The other genre, indecisive, variable, finds its shades there. And thus comes out of the shadows. In the first case, the photograph seems to work less, or rather be less worked over by the dance. It merely reveals a figure. In the second case, it continually reveals itself. Or to be more exact, it keeps opening perspectives which are revealed by the bodies, when they are plunged into the bath of the dance. *Aimées* by Charles Cré-Ange reveals this in an almost unhoped-for way: between a luminous white screen and a dark background, a naked female body, in a paradoxically modest movement, begins to sway and undulate, countering the immobility or the fall of the two male dancers beside her. Between these two static poles, traversed by paralysing streaks of lightning, the female dancer does not yield to the pull of the black or the white, but gives rise to a denuded movement, innate, vague and trembling but detached from these simple opposites (equivalent in their end effect): the collapse or stiffening of the body. A living force between two corpses, this woman is Eve nascent, marvellously detached, involved in a real dance, anything but … evanescent.

That is the work to be done. The labour. This delivery or birth that the instant cannot contain, but which the photograph captures like an origin that is, all at once, timeless, repeated, intermittent, that history brutally scores out, that dance stubbornly, quietly sustains.

"A body become other and as such unseen," said Rilke; a body ceaselessly becoming another and as such close, infinitely close to an existence that cannot be represented. That the photograph distinguishes from afar, making a distinction which is also the only elegant way to look, the only dignified gaze possible.

So these photographs are indeed "aimées"—loved by dance and space and the eye that lights upon them.

Quotations from

BENJAMIN, W., *Origine du drame baroque allemand*. Paris: Flammarion, 1985.

MALLARMÉ, S., *Autre étude de danse*, in *Œuvres completes*.
 Bibliothèque de la Pléiade, Paris: Gallimard, vol. 2.

MICHAUX, H., *Connaissance par les gouffres*, in *Œuvres completes*.
 Bibliothèque de la Pléiade, Paris: Gallimard, vol. 3, 2004.

LACAN, J., *Le Séminaire*, Book 10, "L'Angoisse". Paris: Seuil, 2004.

VALÉRY, P., *L'Âme et la Danse*, in *Œuvres completes*.
 Bibliothèque de la Pléiade, Paris: Gallimard, 1957.

CAPTIONS

1 *Image*
Magali Noiret, Arnaud Cabies,
Else Olhandeguy, Philippe Combeau
Choreography by Michel Kelemenis
Créteil, 1995

2 *Bella Figura*
Eleonora Abbagnato, Jérémie Bélingard
Choreography by Jírí Kylián
Ballet de l'Opéra National de Paris
Paris, 2001

3 *One of a Kind*
Choreography by Jírí Kylián
Nederlands Dans Theater
Paris, 1998

4 *Nocturnes*
Linda Casper
Choreography by Elizabeth Schwartz
Chevilly-Larue, 1985

5 *Le Sacre du printemps*
Philippe Lizon
Choreography by Maurice Béjart
Ballet du xxᵉ siècle
Théâtre royal de la Monnaie de Bruxelles, 1984

6 *Nijinski, clown de Dieu*
Jorge Donn

Choreography by Maurice Béjart
Ballet du xxᵉ siècle, Paris, 1972

7 *Le Voyage*
Jorge Donn
Choreography by Maurice Béjart
Ballet du xxᵉ siècle, Paris, 1970

8 *IXᵉ Symphonie*
Jorge Donn
Choreography by Maurice Béjart
Ballet du xxᵉ siècle, Paris, 1969

9 *IXᵉ Symphonie*
Jorge Donn
Choreography by Maurice Béjart
Ballet du xxᵉ siècle, Paris, 1969

10 *Héliogabale ou l'Anarchiste couronné*
Jorge Donn
Choreography by Maurice Béjart
Ballet du xxᵉ siècle
Paris, 1977

11 *Yoyo*
Jorma Uotinen
Choreography by Jorma Uotinen
Groupe de recherches théâtrales de l'Opéra
de Paris, directed by Carolyn Carlson
Paris, 1979

12 *Rainbow Round My Shoulder*
Sara Yarborough
Choreography by Donald Mc Kayle
Alvin Ailey Dance Theatre
Paris, 1974

13 *Carmina Burana*
Sara Yarborough
Choreography by John Butler
Alvin Ailey Dance Theatre
Avignon, 1974

14 *Carmina Burana*
Clive Thomson
Choreography by John Butler
Alvin Ailey Dance Theatre
Avignon, 1974

15 *Rainbow Round My Shoulder*
Sara Yarborough
Choreography by Donald Mc Kayle
Alvin Ailey Dance Theatre
Paris, 1974

16 *Carmina Burana*
Michihiko Oka, Sara Yarborough,
Judith Jamison
Choreography by John Butler
Alvin Ailey Dance Theatre
Avignon, 1974

17 *Rainbow Round My Shoulder*
Sara Yarborough
Choreography by Donald Mc Kayle
Alvin Ailey Dance Theatre
Paris, 1974

18 *Ubushuna* («Danse de l'hiver»)
Takeshi Yazaki
Choreography by Susan Buirge
Avignon, 1998

19 *Ubushuna* («Danse de l'hiver»)
Mikayo Mori
Choreography by Susan Buirge
Avignon, 1998

20 *Sylvia*
Nicolas Le Riche, étoile
Choreography by John Neumeier
Ballet de l'Opéra National de Paris
Paris, 2003

21 *Limbs Theorem*
Choreography by William Forsythe
Ballett Frankfurt
Paris, 1996

22 *Dance*
Choreography by Lucinda Childs
Maisons-Alfort, 1995

23 *Dance*
Choreography by Lucinda Childs
Maisons-Alfort, 1995

24 *Dance*
Choreography by Lucinda Childs
Maisons-Alfort, 1995

25 *That*
Carolyn Carlson
étoile and choreographer
Groupe de recherches théâtrales
de l'Opéra de Paris
Paris, 1977

26 *Messe pour le temps futur*
Shonah Mirk, Ronald Perry
Choreography by Maurice Béjart
Ballet du xx^e siècle
Paris, 1984

27 *Limbs Theorem*
Thomas McManus
Choreography by William Forsythe
Ballett Frankfurt
Paris, 1996

28 *Ursonate*
Choreography by Bill T. Jones
Avignon, 1996

29 *White Dreams*
Choreography by Graciela Martinez
Paris, 1975

30 *Le Silence des sirènes*
Brigitte Asselineau
Choreography by Christine Gérard
and Daniel Dobbels
Paris, 1984

31 *Roméo et Juliette*
Susan Farrell
Choreography by Maurice Béjart
La Courneuve, 1972

32 *Image, Clin de lune*
Michel Kelemenis
Choreography by Michel Kelemenis
Créteil, 1995

33 *Fragments*
Shonah Mirk
Choreography by Maurice Béjart
Ballet du xx^e siècle
Paris, 1984

34 *Split Sides*
Derry Swan, Cédric Andrieux
Choreography by Merce Cunningham
Paris, 2003

54 *Abel, Abeth*
Guilaine Londez, Agnès Dufour,
Pascal Allio
Choreography by Christine Bastin
Bezons, 1995

55 *Tabou*
Marceline Lartigue
Choreography by Marceline Lartigue
Évry, 1995

56 *Mirage*
Collective choreography
Pilobolus Dance Theatre
Paris, 1984

57 *Kagemi*
Sankai Juku
Choreography by Ushio Amagatsu
Paris, 2000

58 *Kagemi*
Sankai Juku
Choreography by Ushio Amagatsu
Paris, 2000

59 *Cry*
Judith Jamison
Choreography by Alvin Ailey
Alvin Ailey Dance Theatre, Paris, 1974

60 *Le Silence des sirènes*
Brigitte Asselineau
Choreography by Christine Gérard
and Daniel Dobbels, Paris, 1984

61 *Hypothetical Stream*
Choreography by William Forsythe
Ballett Frankfurt, Paris, 1998

62 *Sonate à trois*
Carole Arbo, Élisabeth Maurin,
Laurent Hilaire, étoile
Choreography by Maurice Béjart
Ballet de l'Opéra National de Paris
Paris, 1995

63 *La Fontaine de Bachkisaraï*
Sylvie Guillem, étoile
Choreography by Rotislav Zakharov
Ballet du Theâtre Kirov-Marinski
Paris, 1994

64 *Apollon Musagète*
Rudolf Noureyev
Choreography by George Balanchine
Ballet de l'Opéra de Paris
Paris, 1972

65 *Giselle*
Galina Ulanova
Bolshoi Theatre
Opéra National de Paris
Paris, 1958

66 Rudolf Nureyev
after *La Belle au bois dormant*
Kirov Theatre Ballet
Opéra de Paris
Paris, 1961

67 *Nijinski, clown de Dieu*
Paolo Bortoluzzi
Choreography by Maurice Béjart
Ballet du xxᵉ siècle
Paris, 1971

68 *Pli selon Pli*
Choreography by Maurice Béjart
Ballet du xxᵉ siècle
Paris, 1976

69 *Foi*
Choreography by Sidi Larbi Cherkaoui
Les Ballets contemporains de la Belgique
(Les Ballets C. de la B.)
Paris, 2003

70 *Hélicoptère*
Choreography by Angelin Preljocaj
Créteil, 2001

105 *Lamentation*
Fanny Gaïda, étoile
Choreography by Martha Graham
Ballet de l'Opéra National de Paris
Paris, 1998

106 *Lamentation*
Fanny Gaïda, étoile
Choreography by Martha Graham
Ballet de l'Opéra National de Paris
Paris, 1998

107 *Lamentation*
Fanny Gaïda, étoile
Choreography by Martha Graham
Ballet de l'Opéra National de Paris
Paris, 1998

108 *Lamentation*
Fanny Gaïda, étoile
Choreography by Martha Graham
Ballet de l'Opéra National de Paris
Paris, 1998

109 *Lamentation*
Peggy Lyman
Choreography by Martha Graham
Martha Graham Dance Cie
Paris, 1976

110 *Giselle*
Jean-Pierre Bonnefous
Choreography by Alicia Alonso
Ballet de l'Opéra de Paris
Paris, 1972

111 *Giselle*
Violette Verdy
Choreography by Alicia Alonso
Ballet de l'Opéra de Paris
Paris, 1972

112 *The Cage*
Sabrina Brazzo, Andrea Volpintesta
Choreography by Jerome Robbins
Corpo di Ballo del Teatro alla Scala
Teatro degli Arcimboldi, Milano, 2004

113 *The Cage*
Sabrina Brazzo, Andrea Volpintesta
Choreography by Jerome Robbins
Corpo di Ballo del Teatro alla Scala
Teatro degli Arcimboldi
Milano, 2004

114 *Nana et Lila*
Choreography by Blanca Li
Nanterre, 1995

115 *Le Lac des cygnes*
Choreography by
Vladimir Bourmeister,
Lev Ivanov, Marius Petipa
Ballet de l'Opéra de Paris
Paris, 1976

116 Maia Plissetskaia
after *Isadora*
Ballet de Maurice Béjart
Cour carrée du Louvre
Paris, 1977

MARION - VALENTINE

To my father, Edmond Suchar
To all dancers, conveyors of emotion

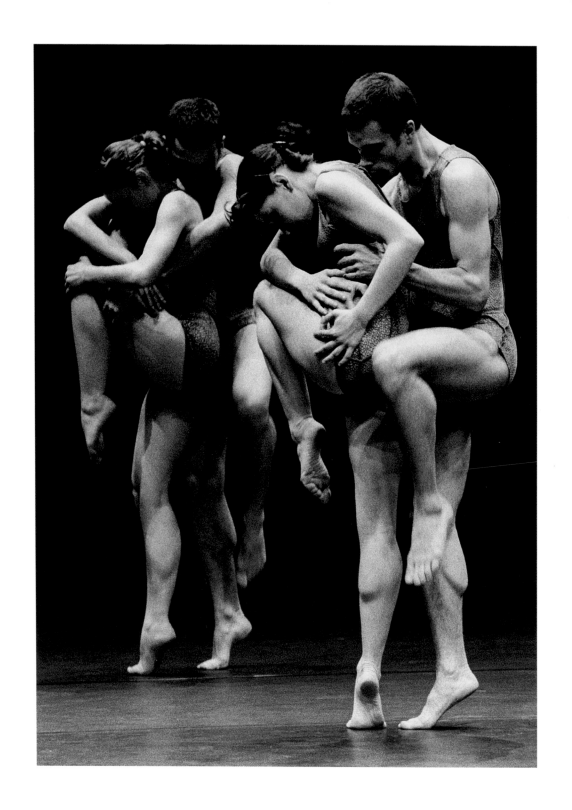

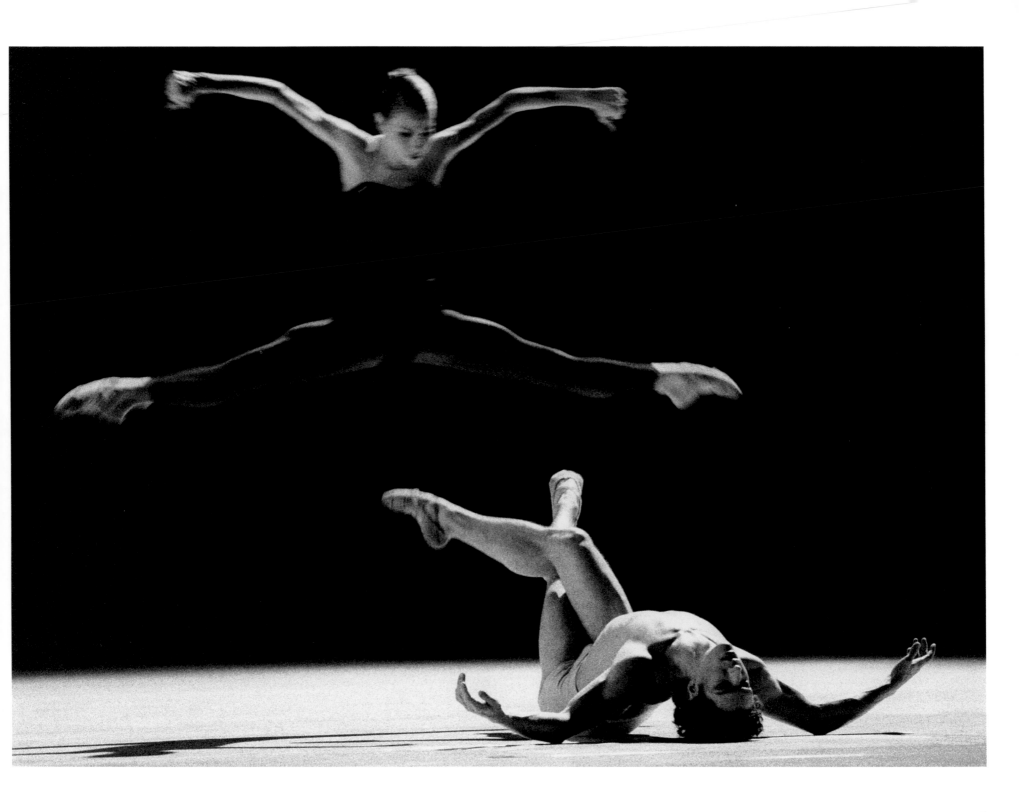

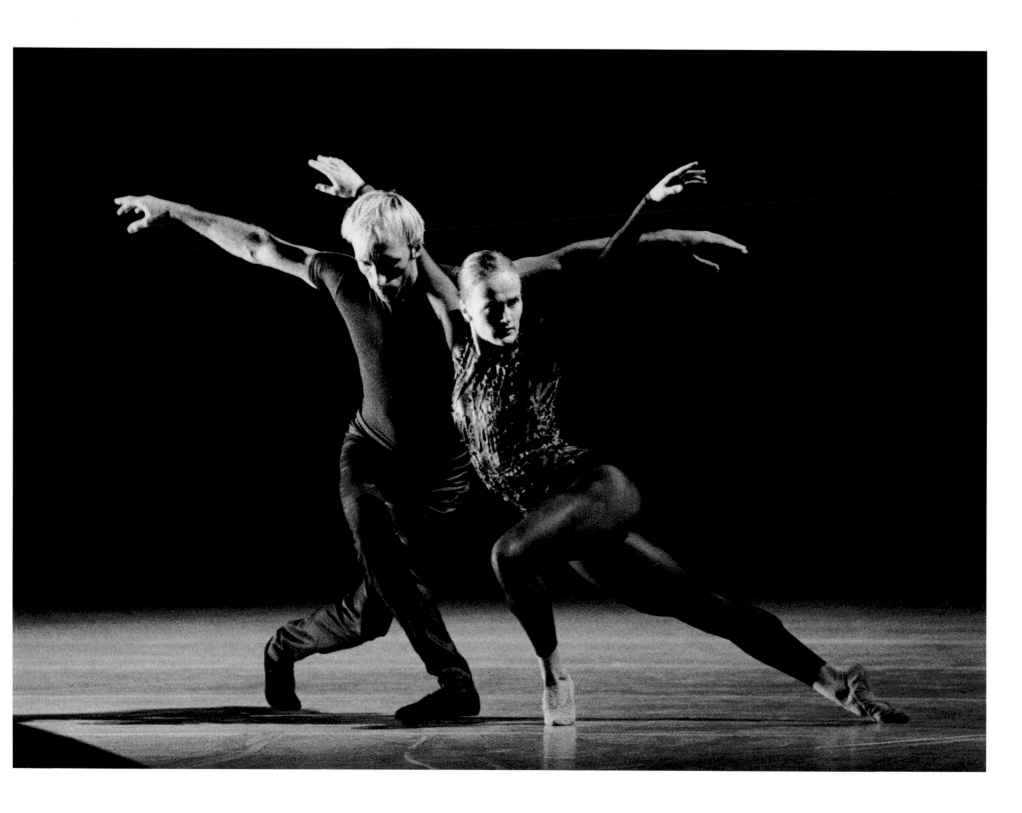

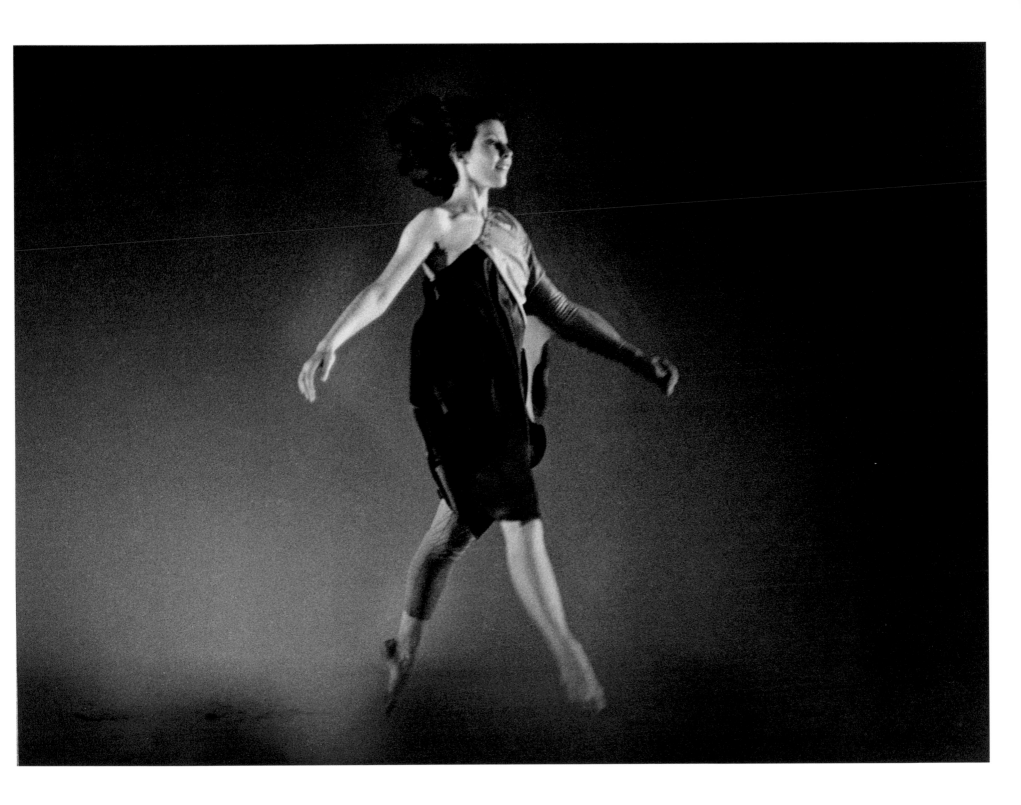

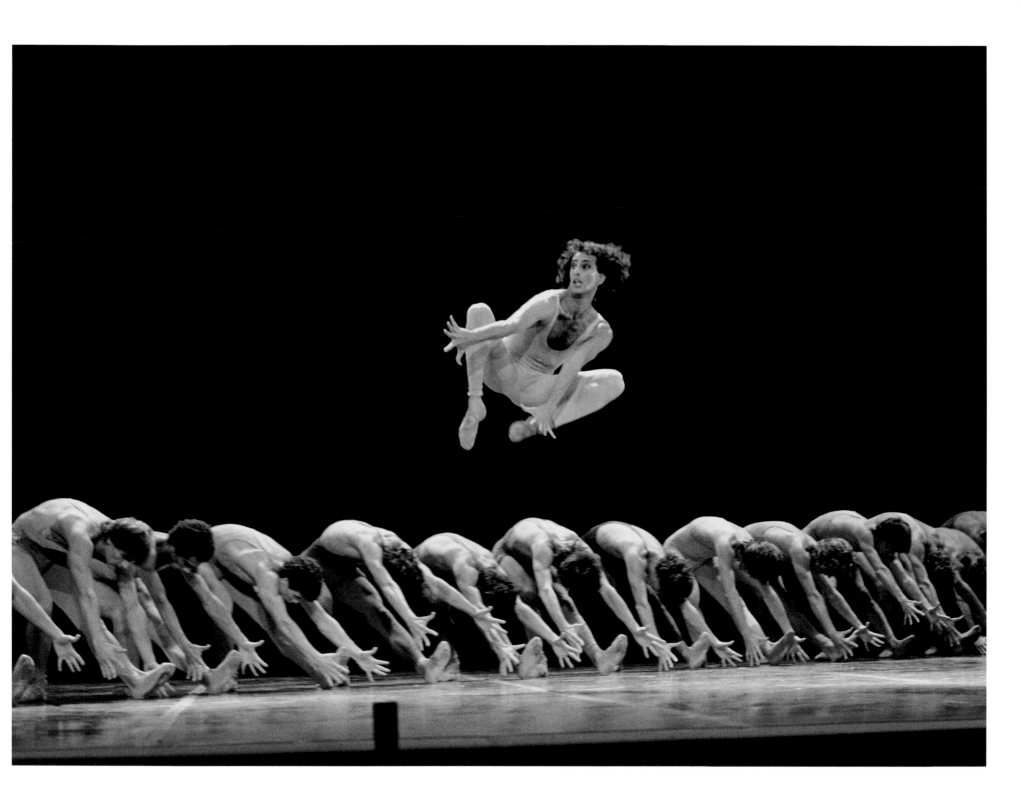

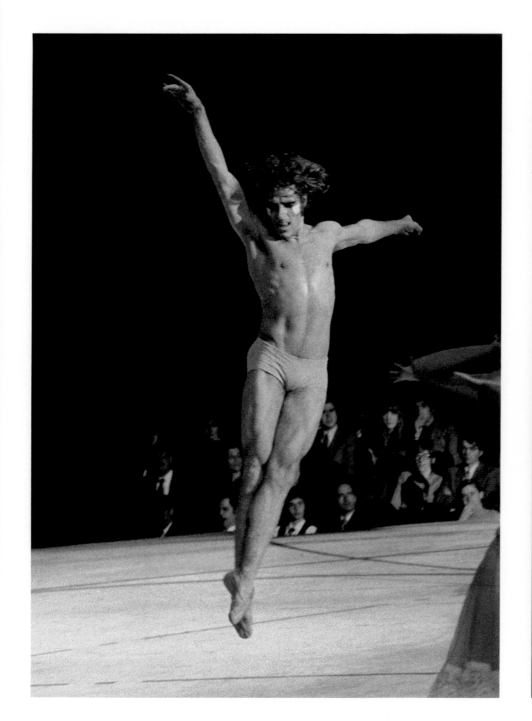

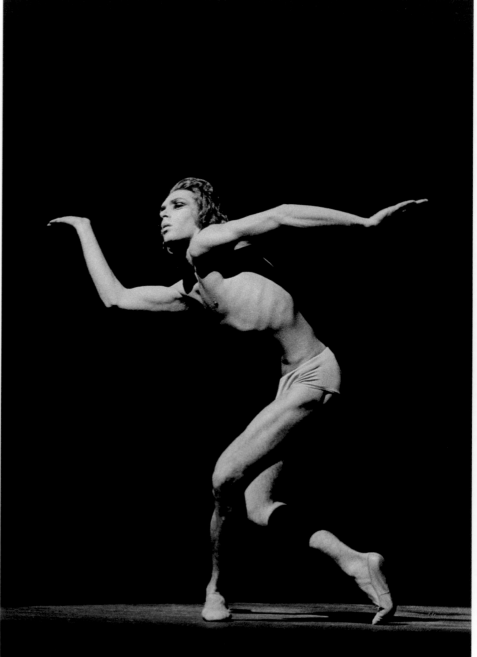

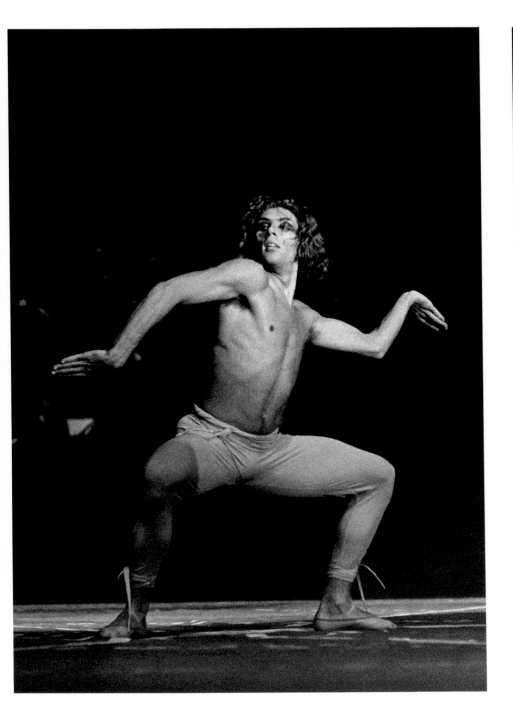
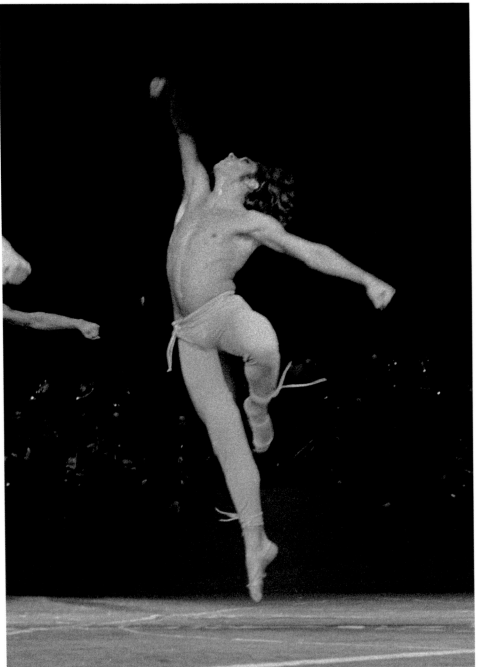

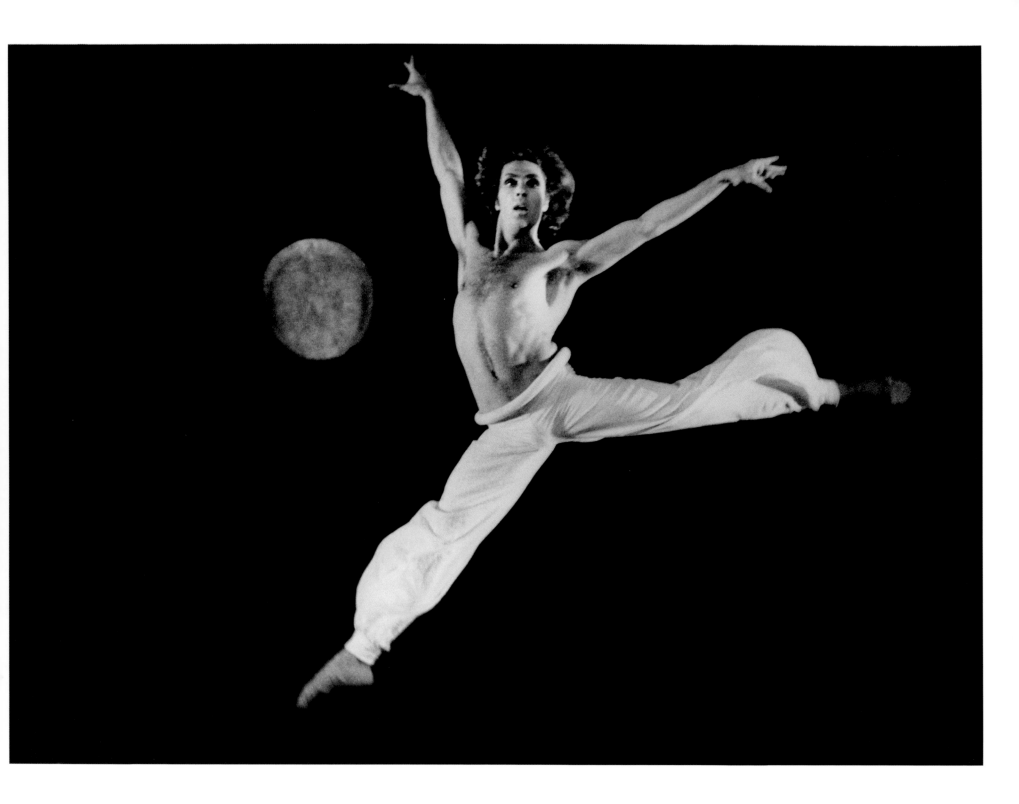

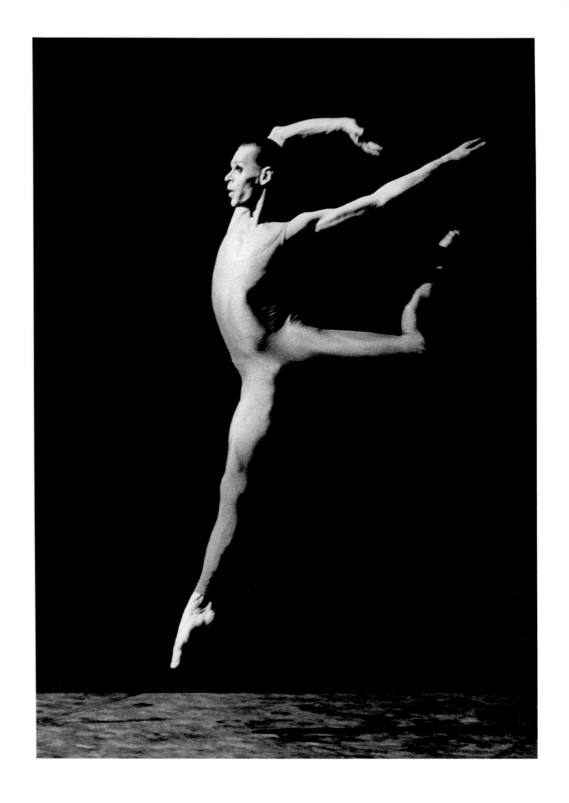

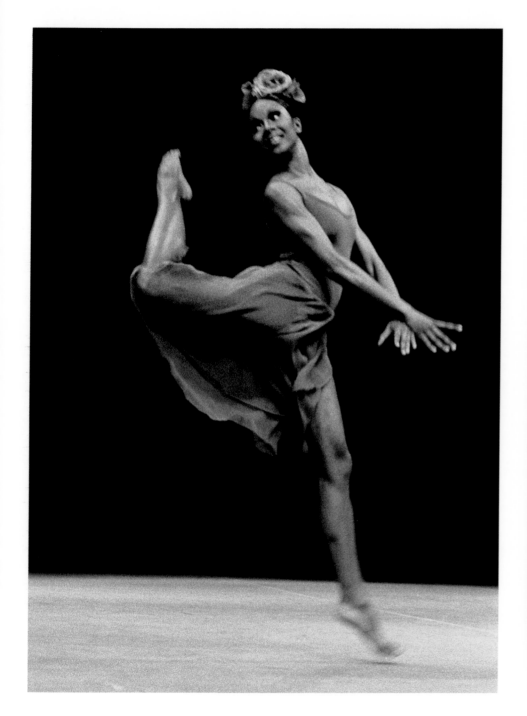

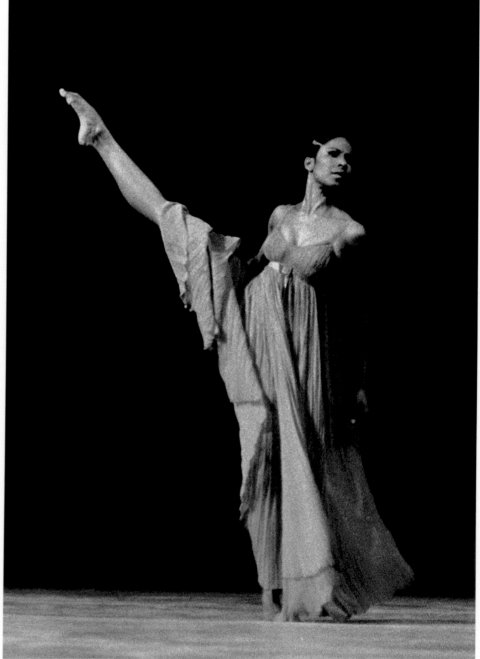

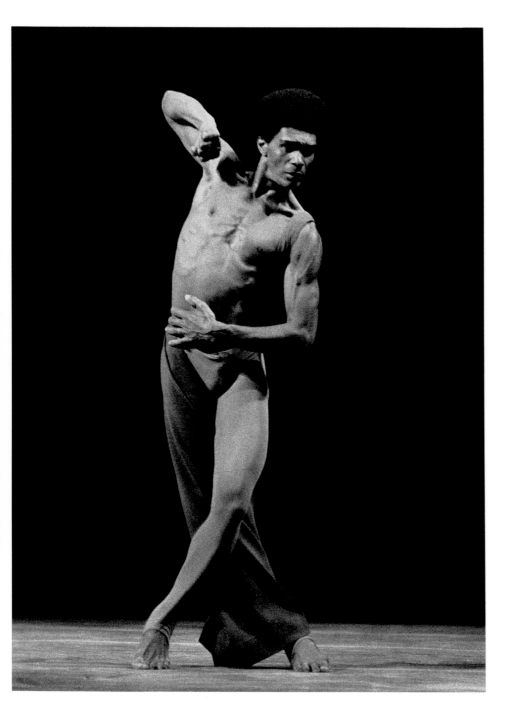

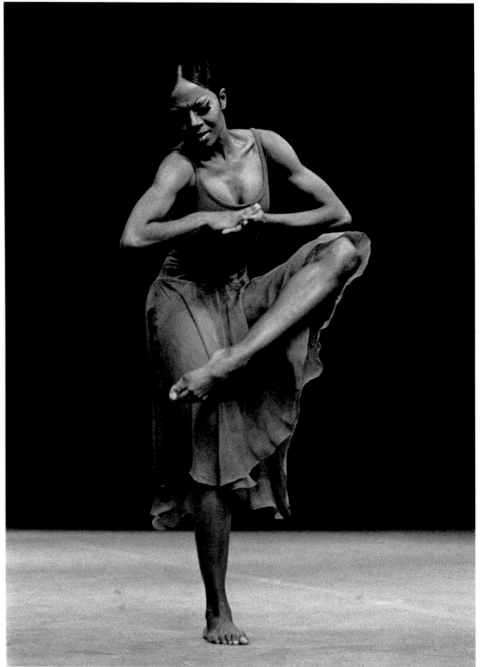

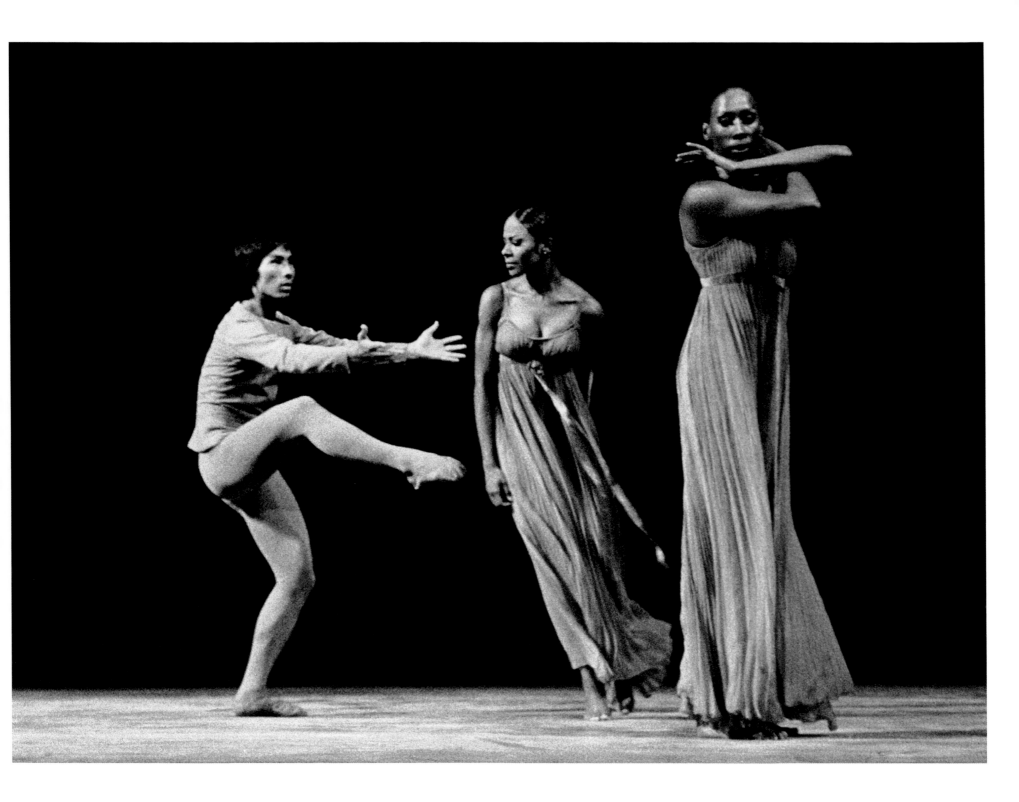

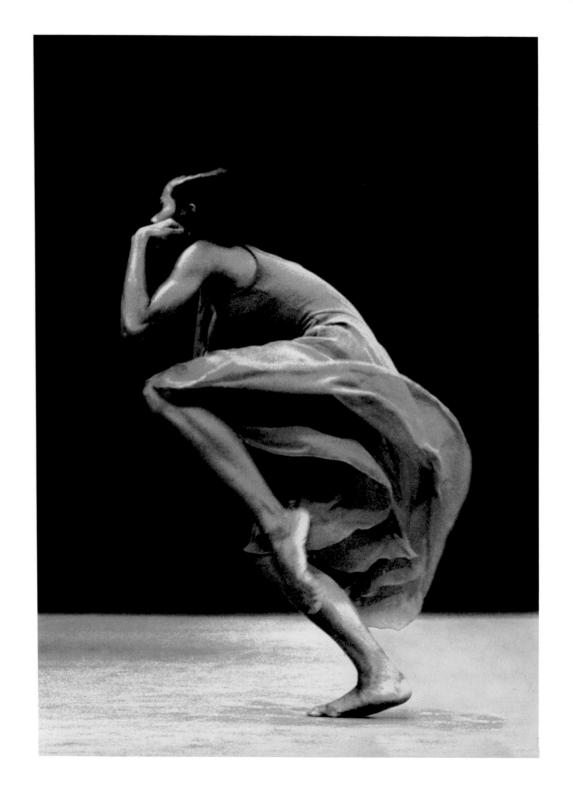

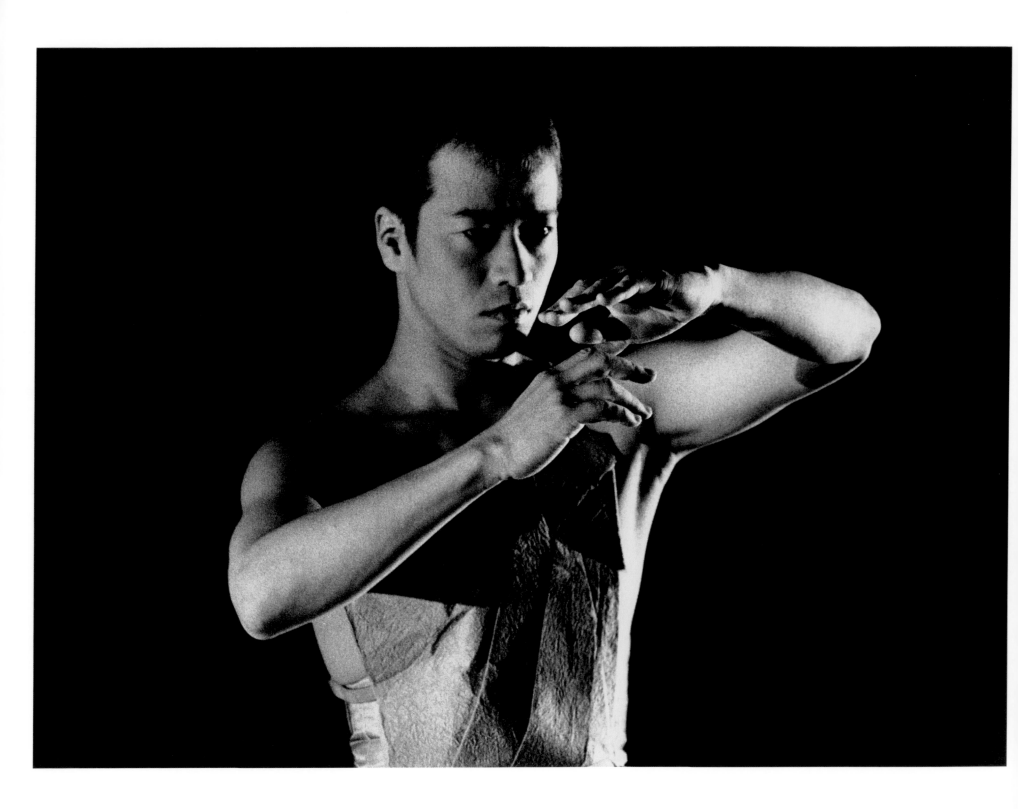

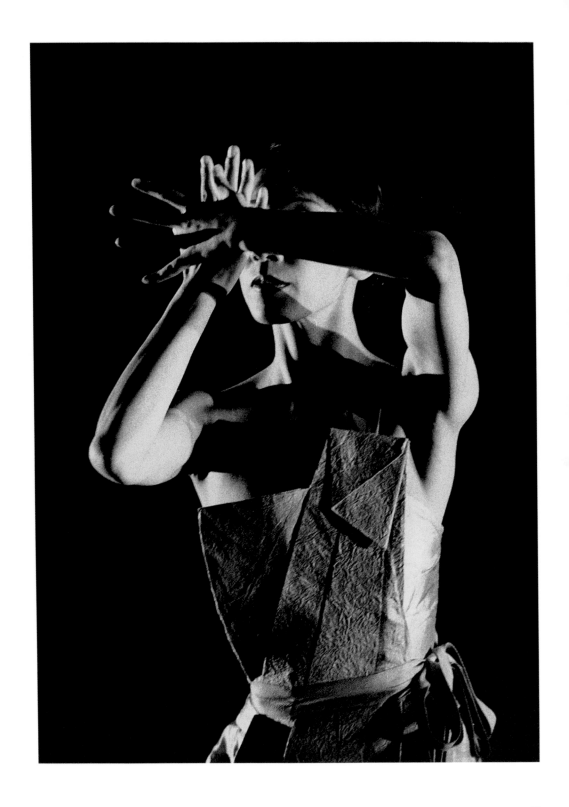

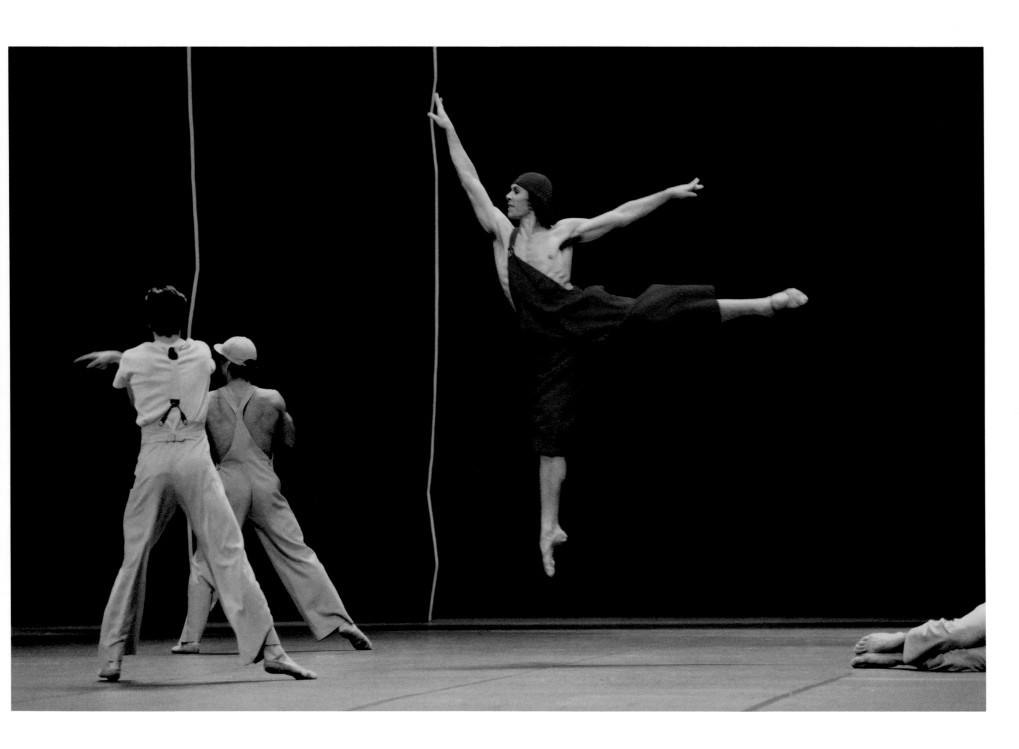

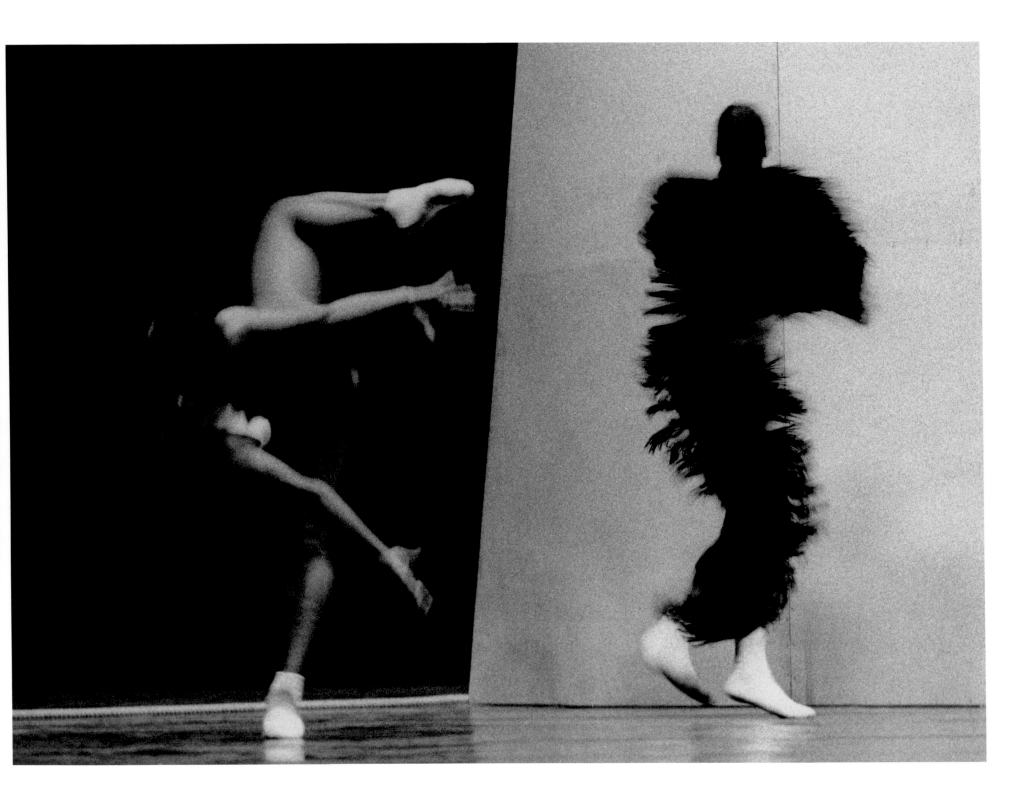

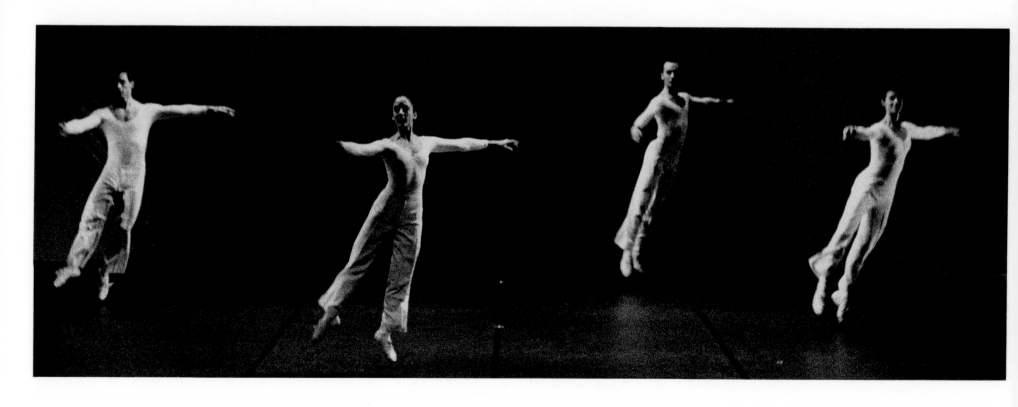

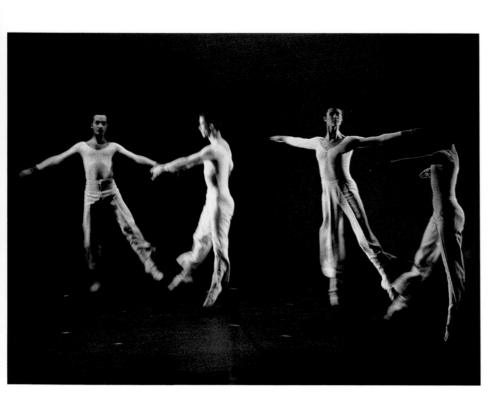
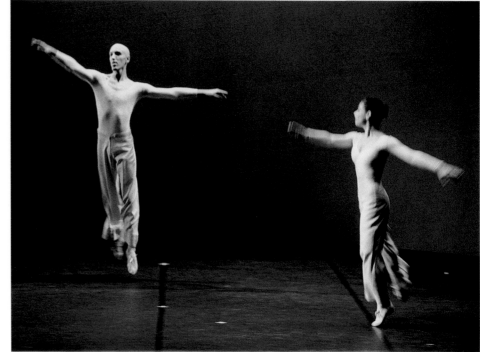

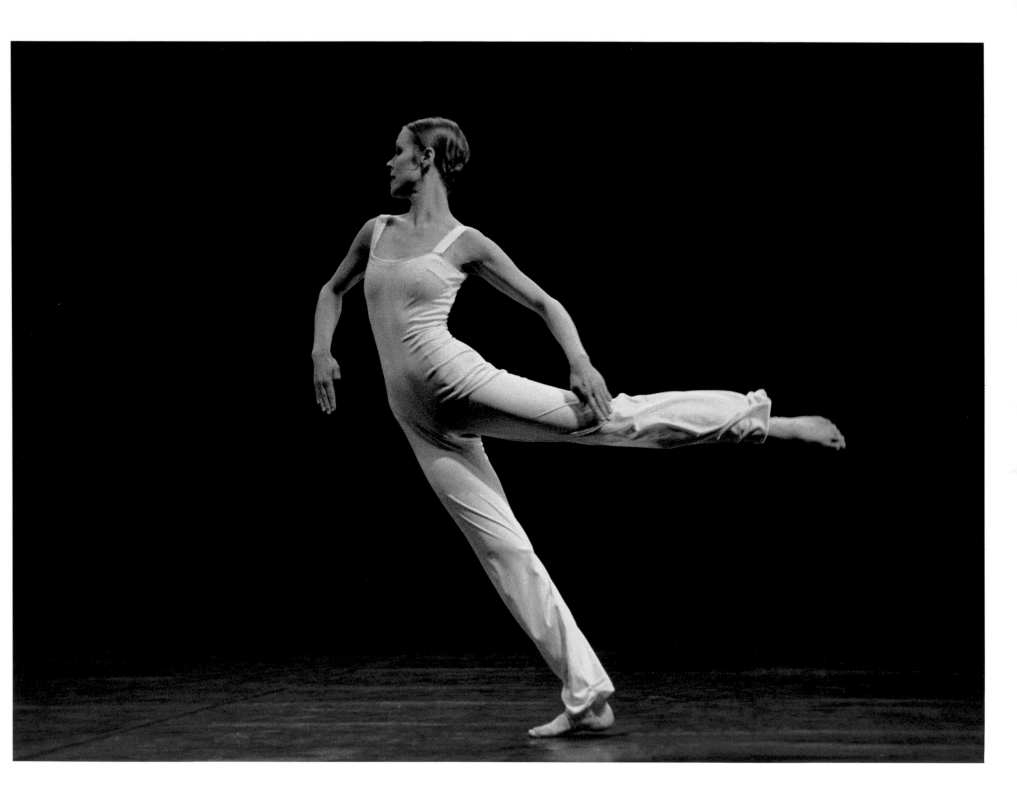

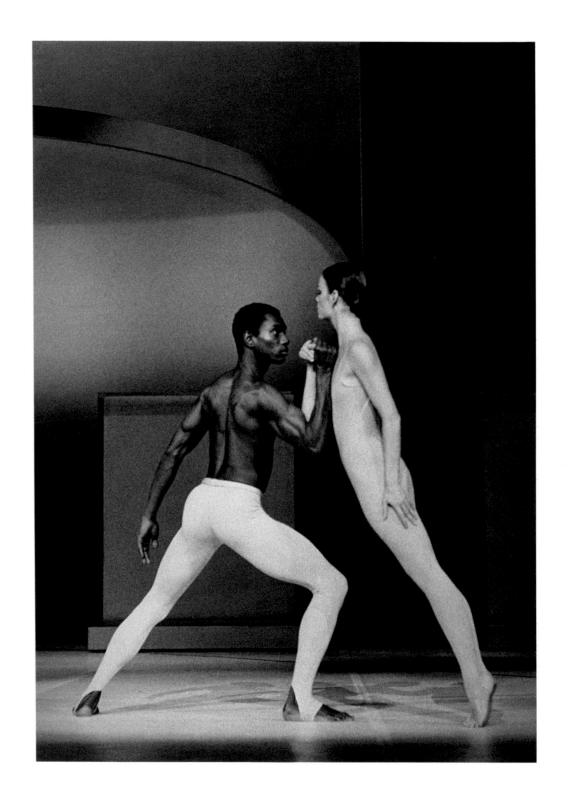

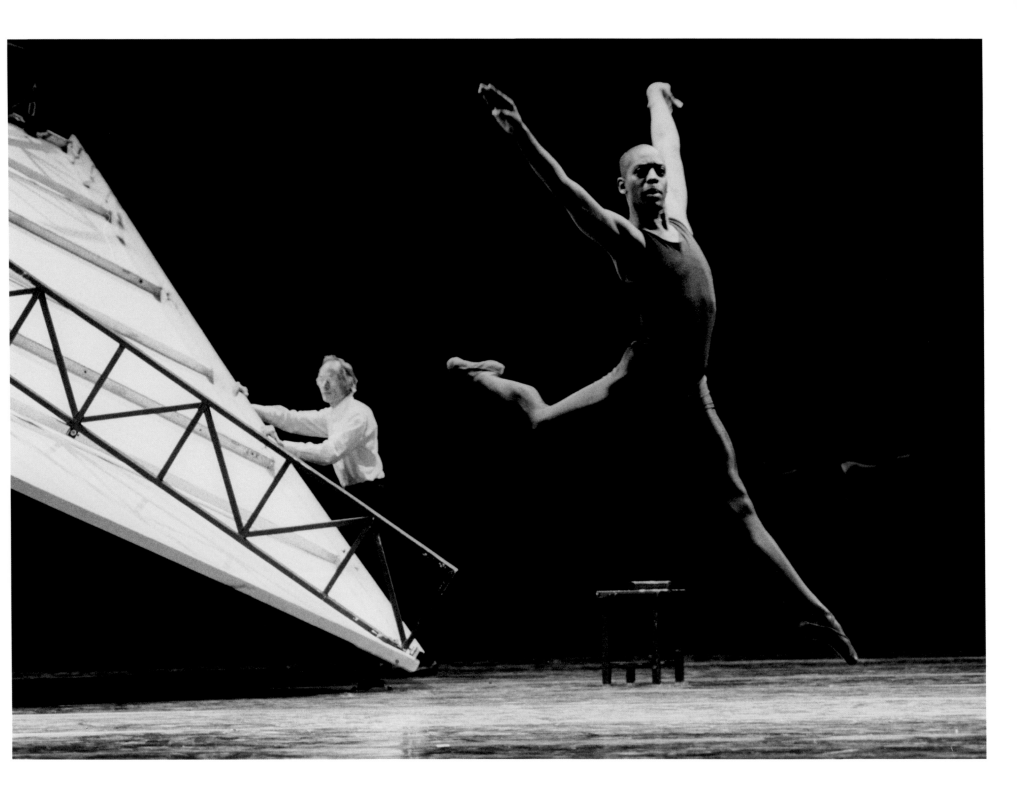

27

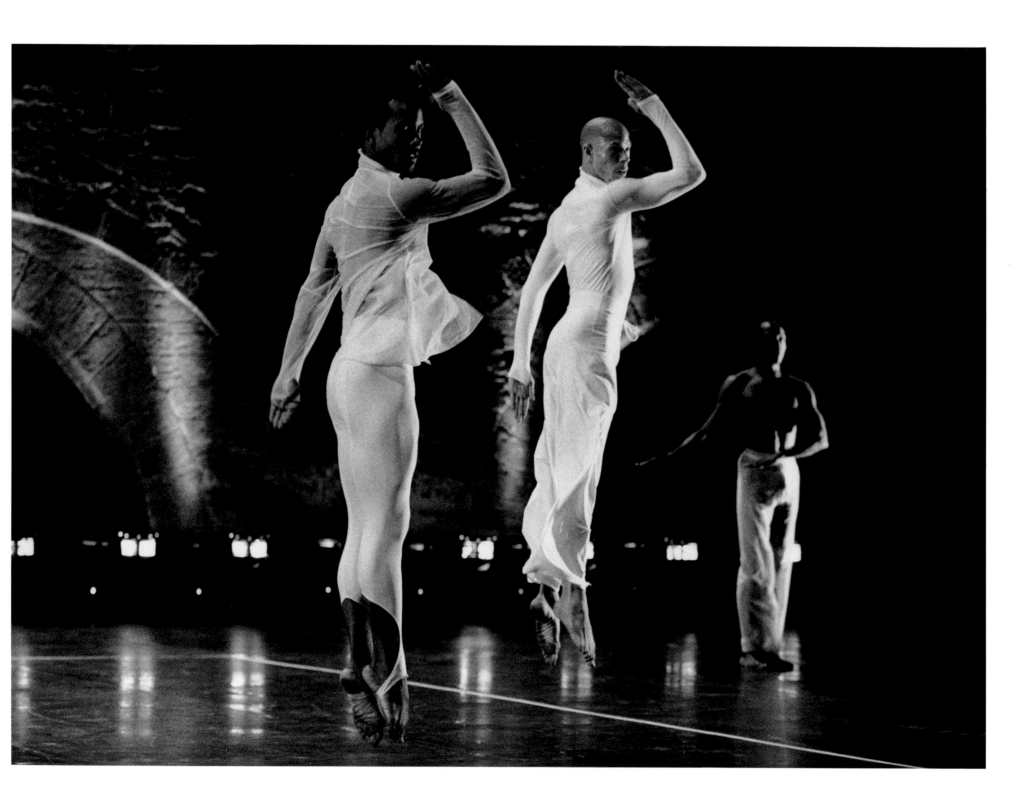

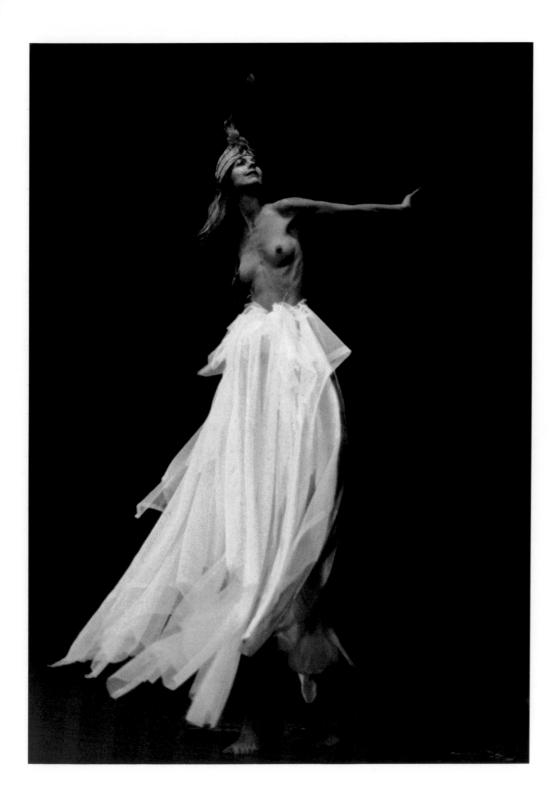

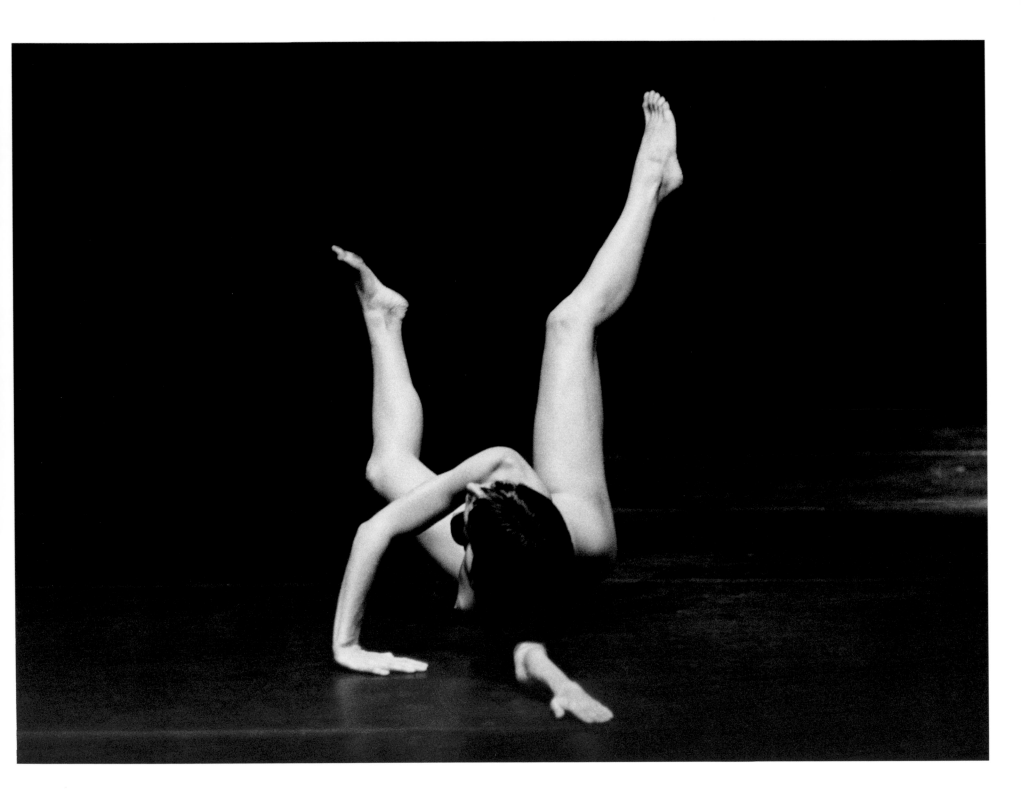

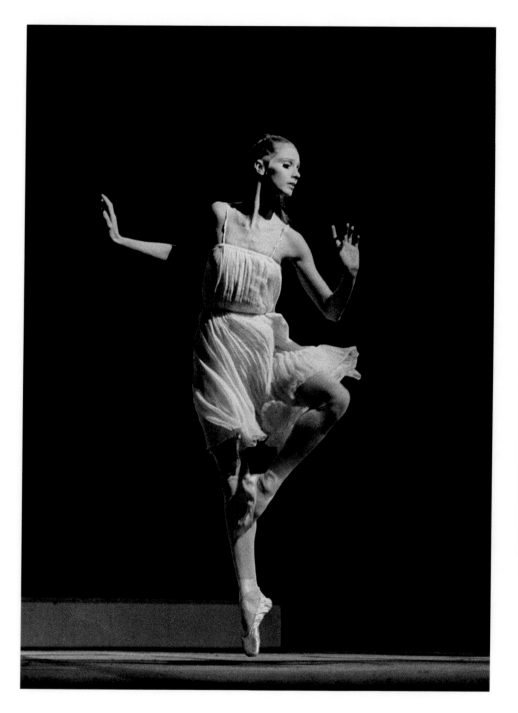
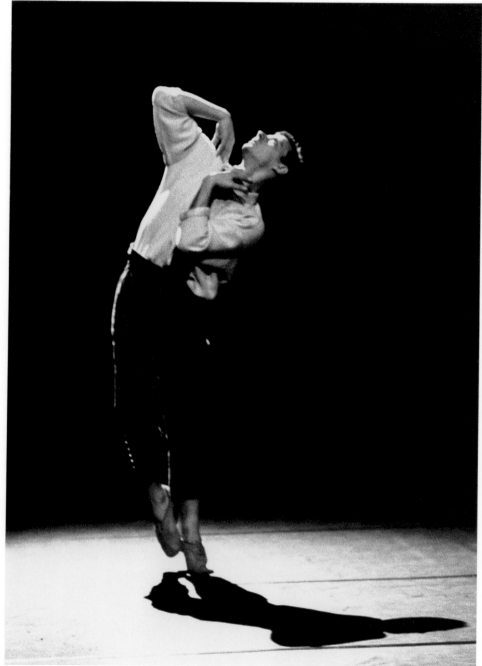

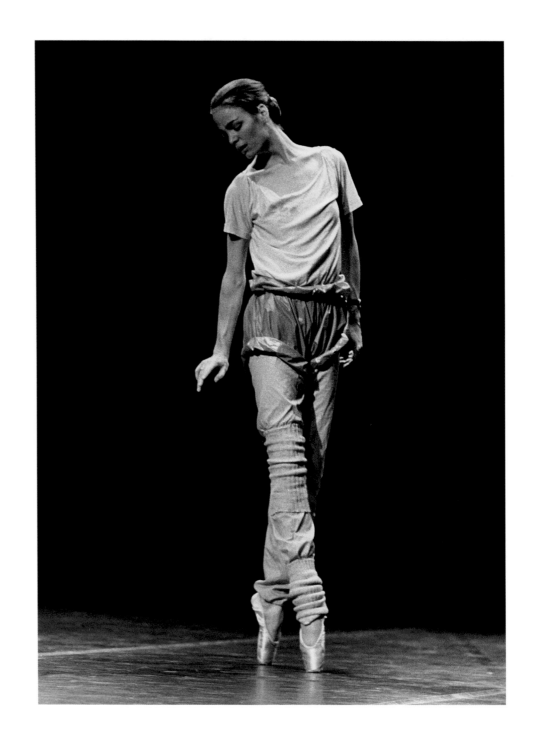

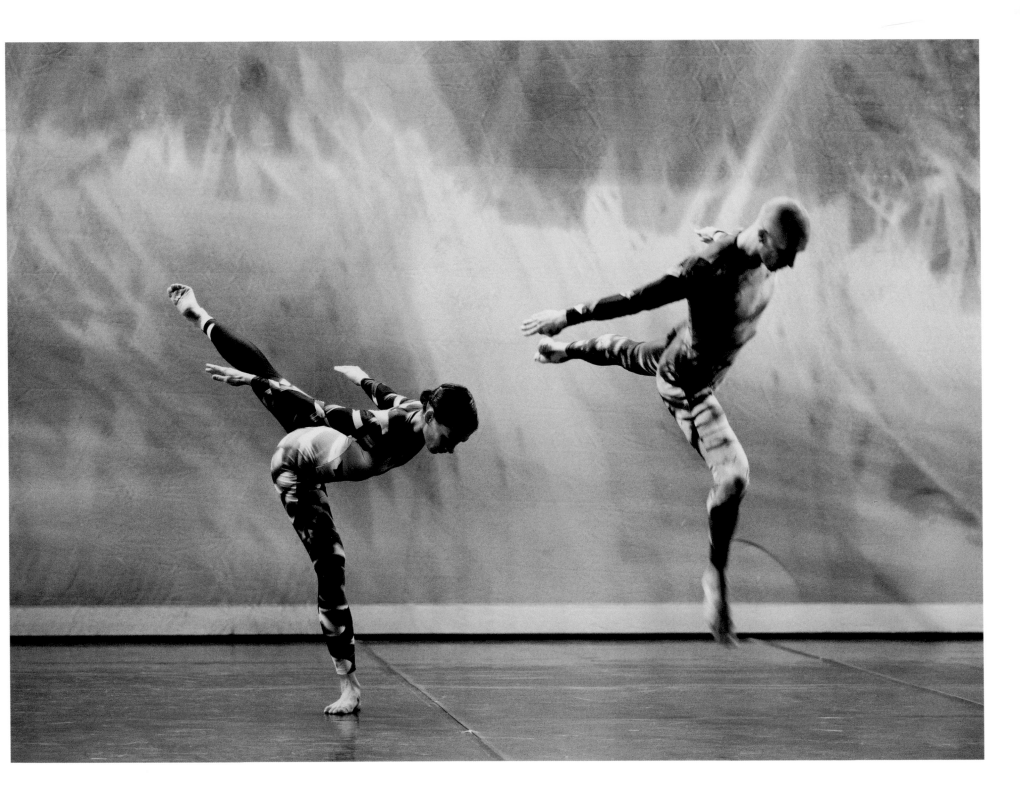

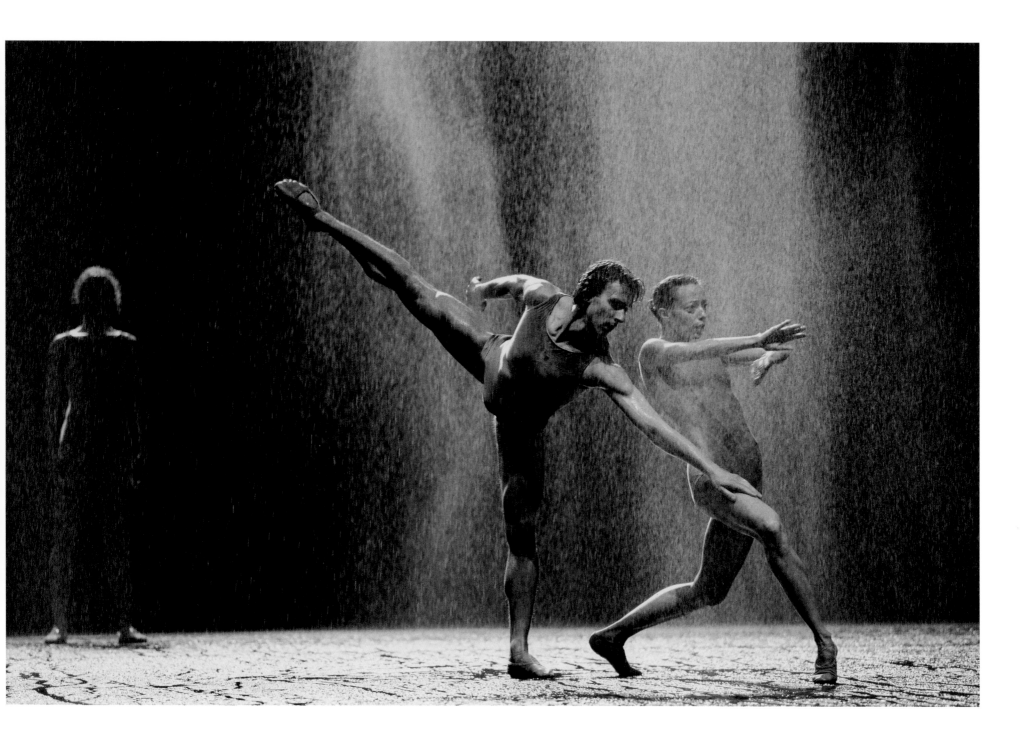

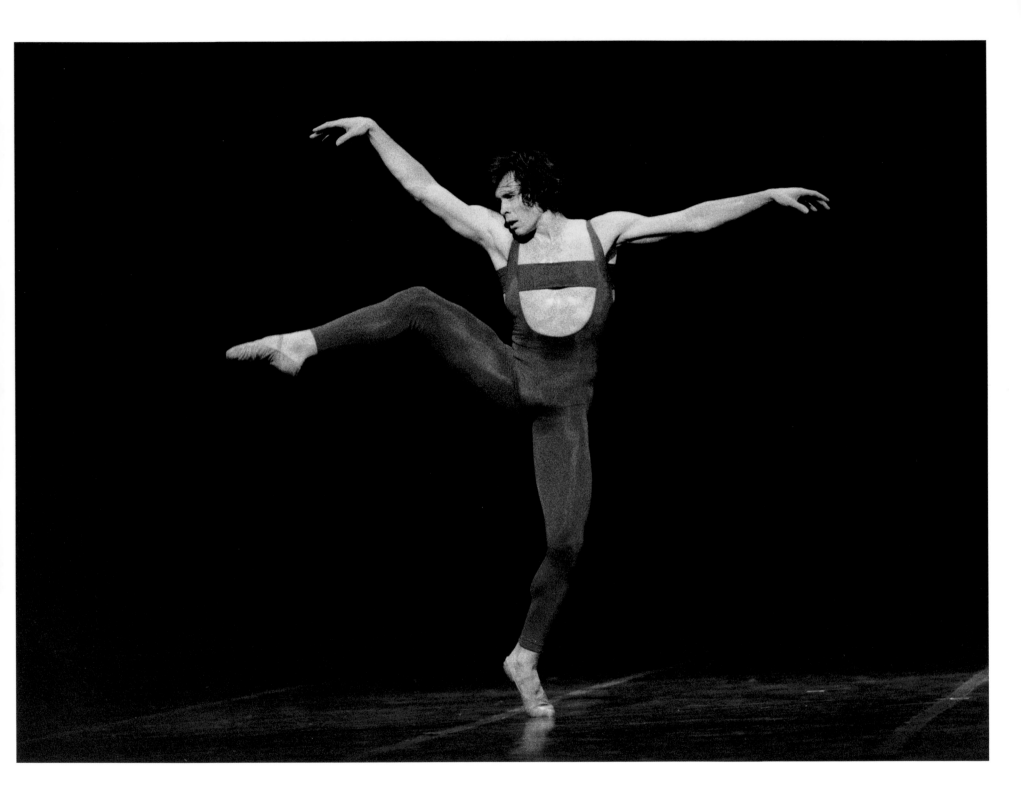

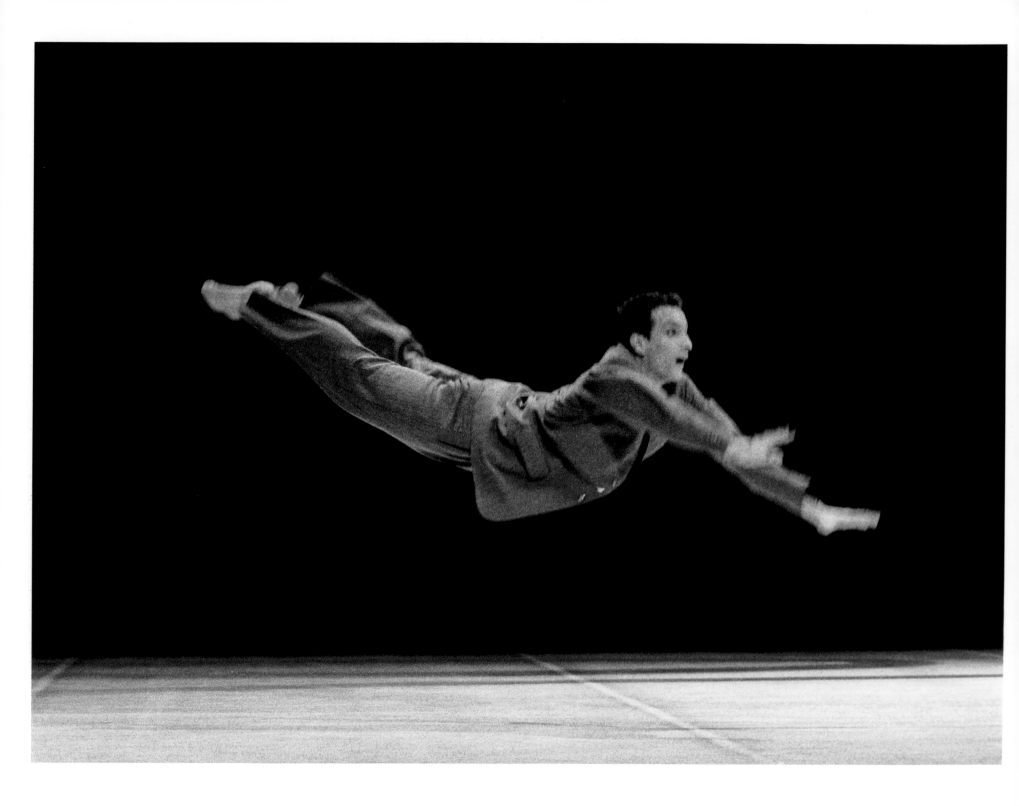

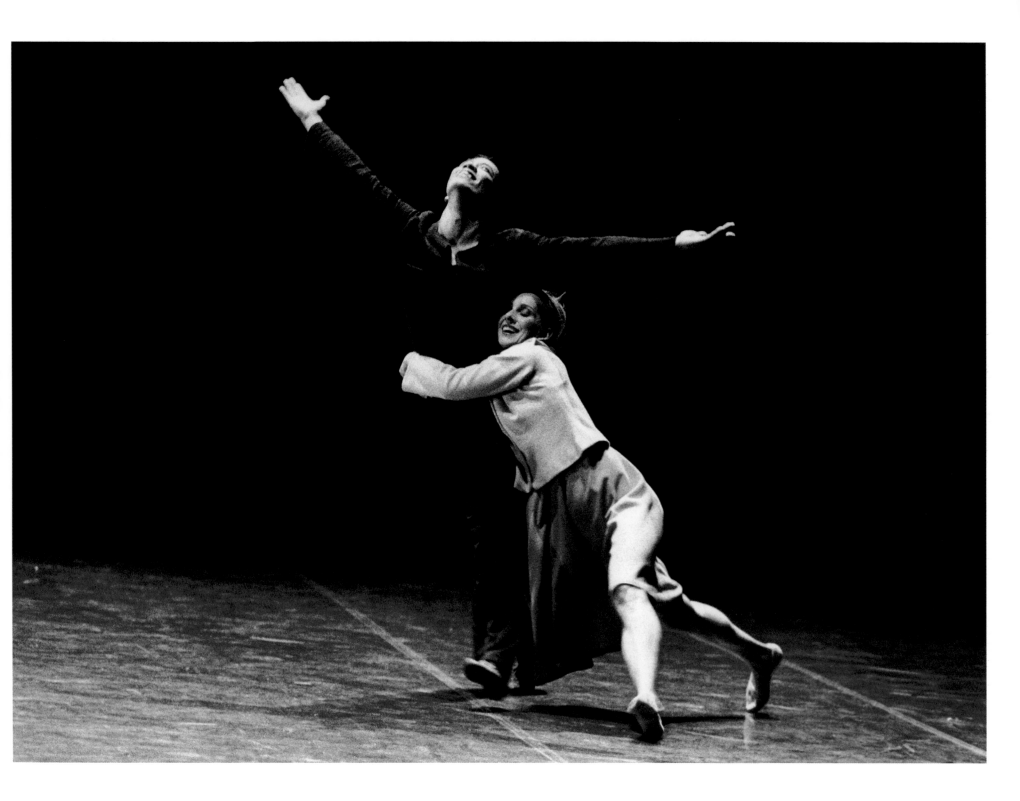

38

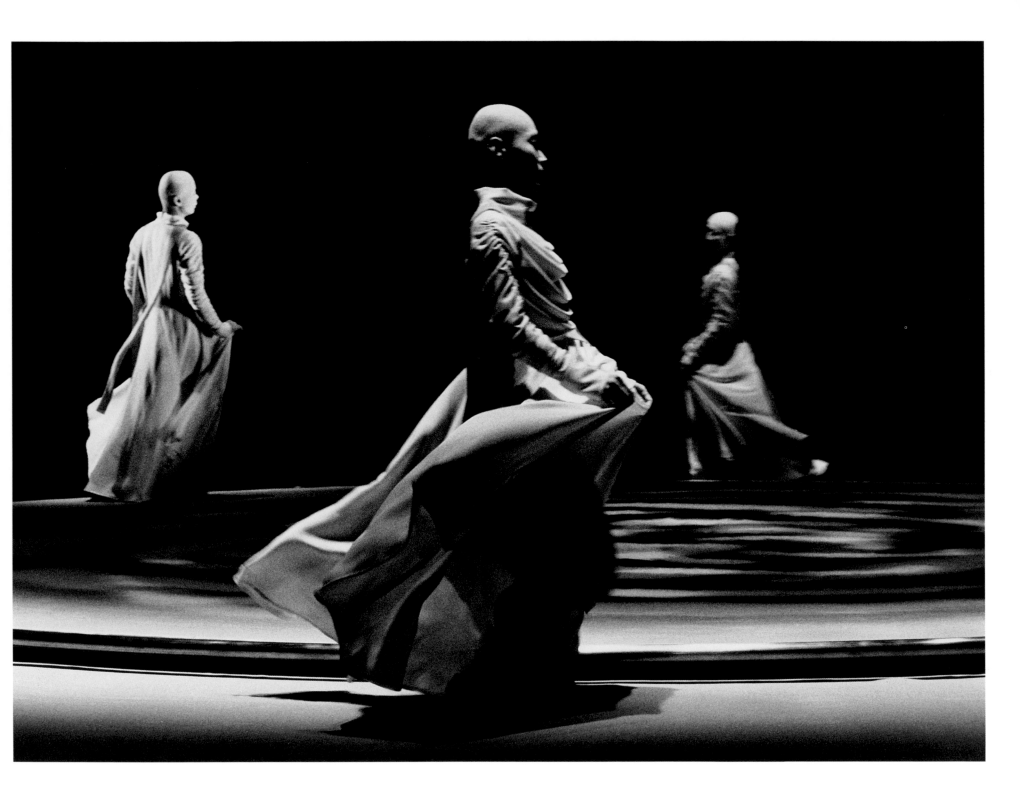

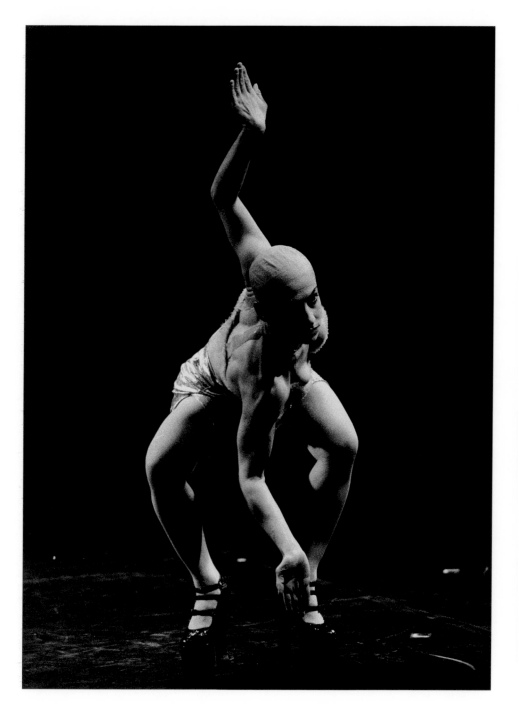
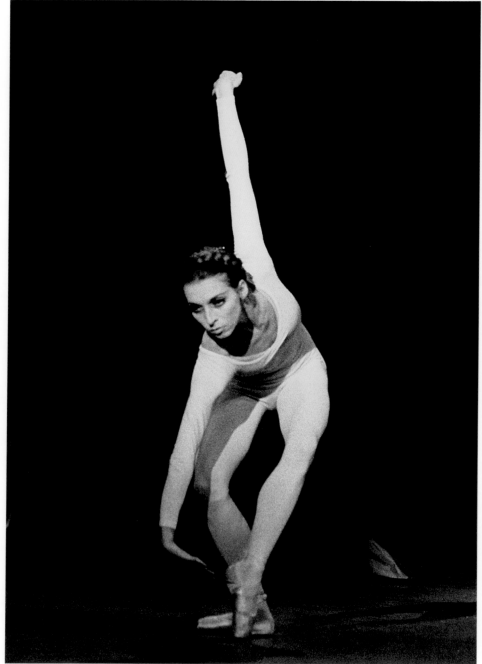

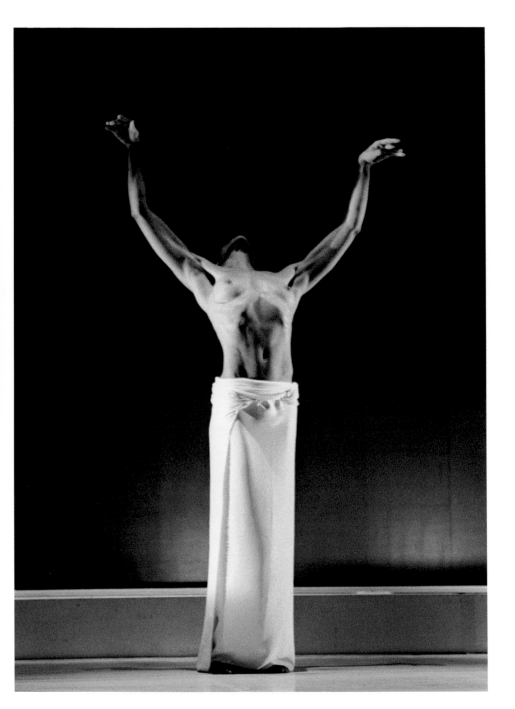

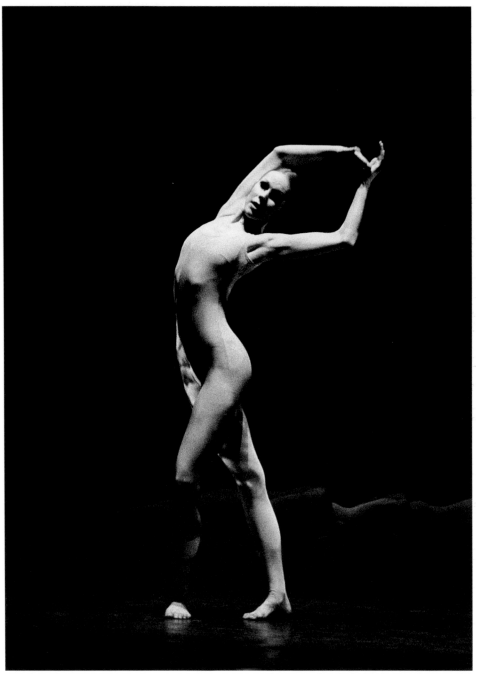

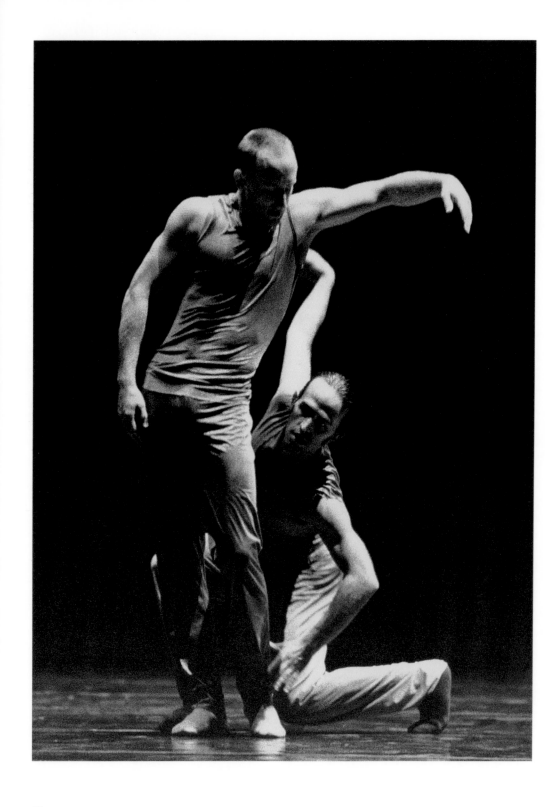

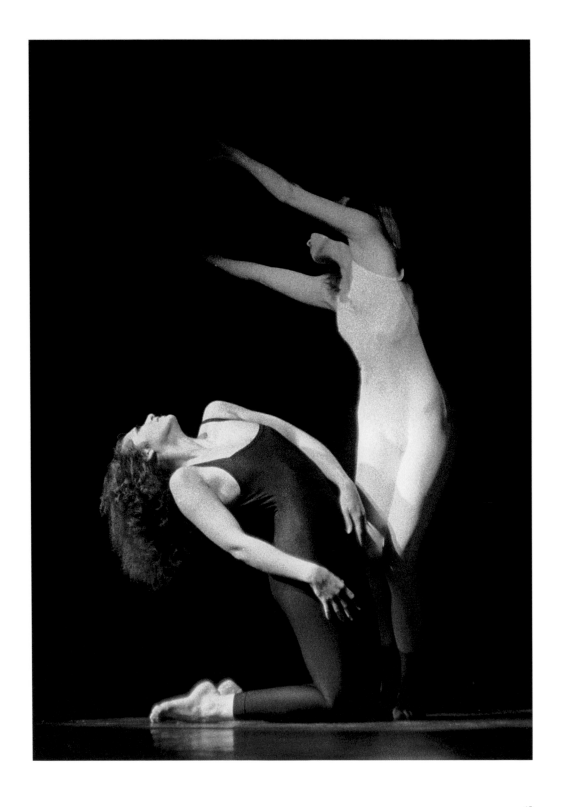

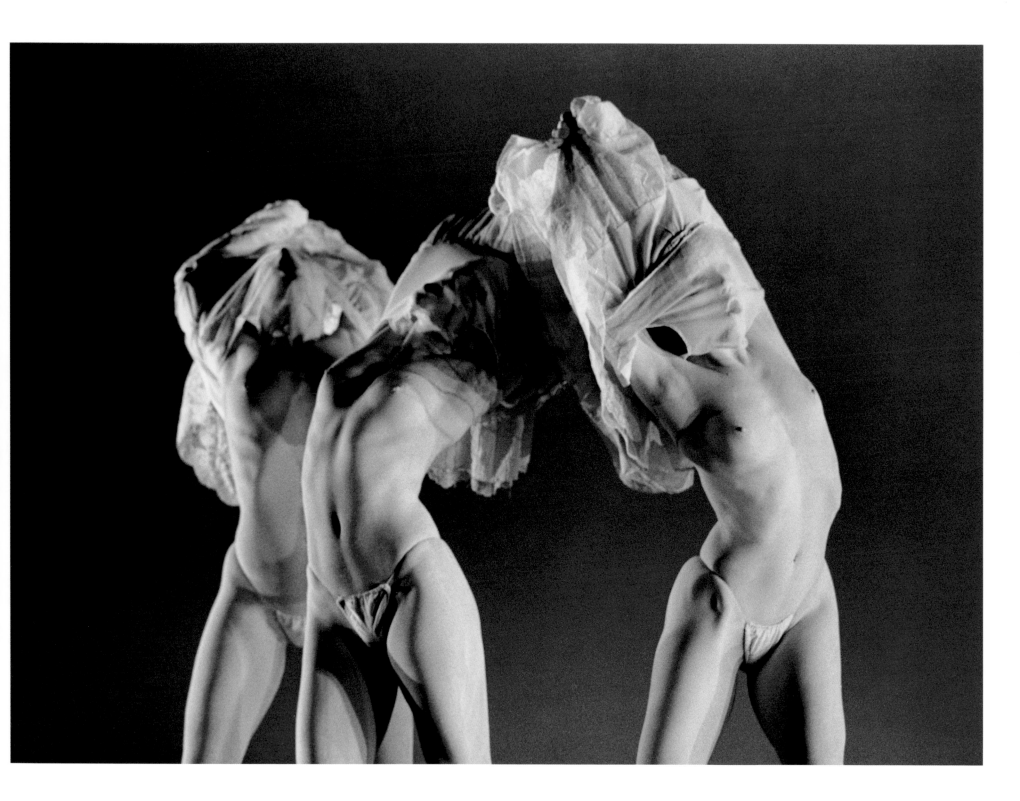

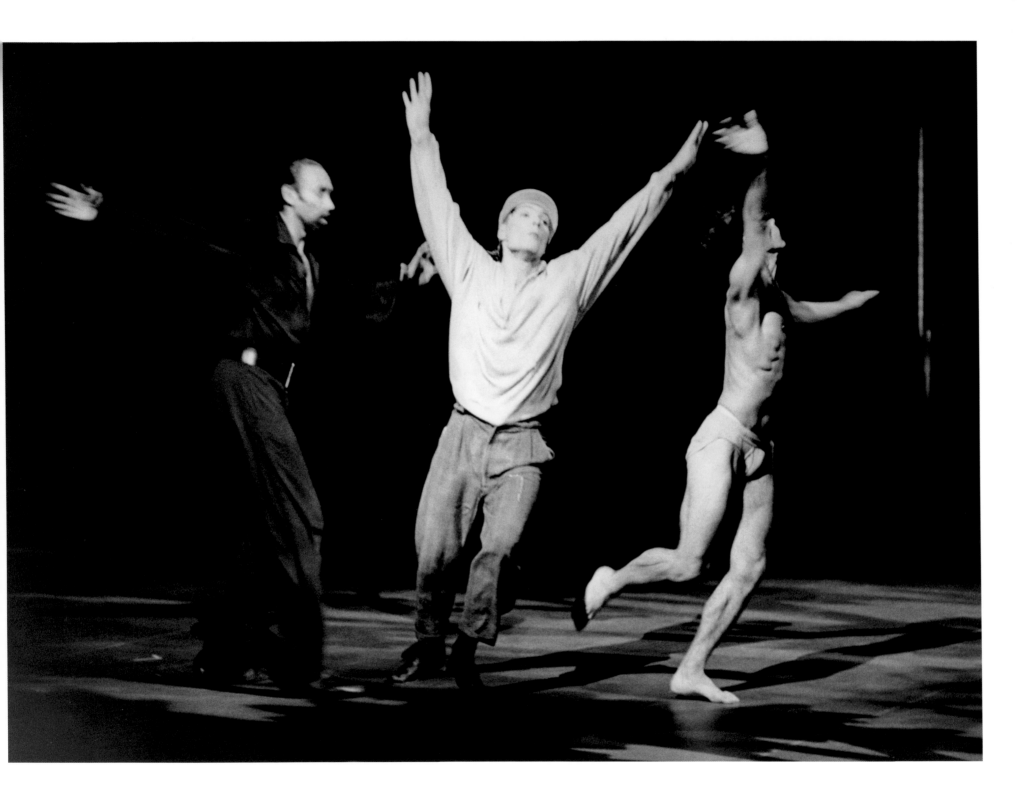

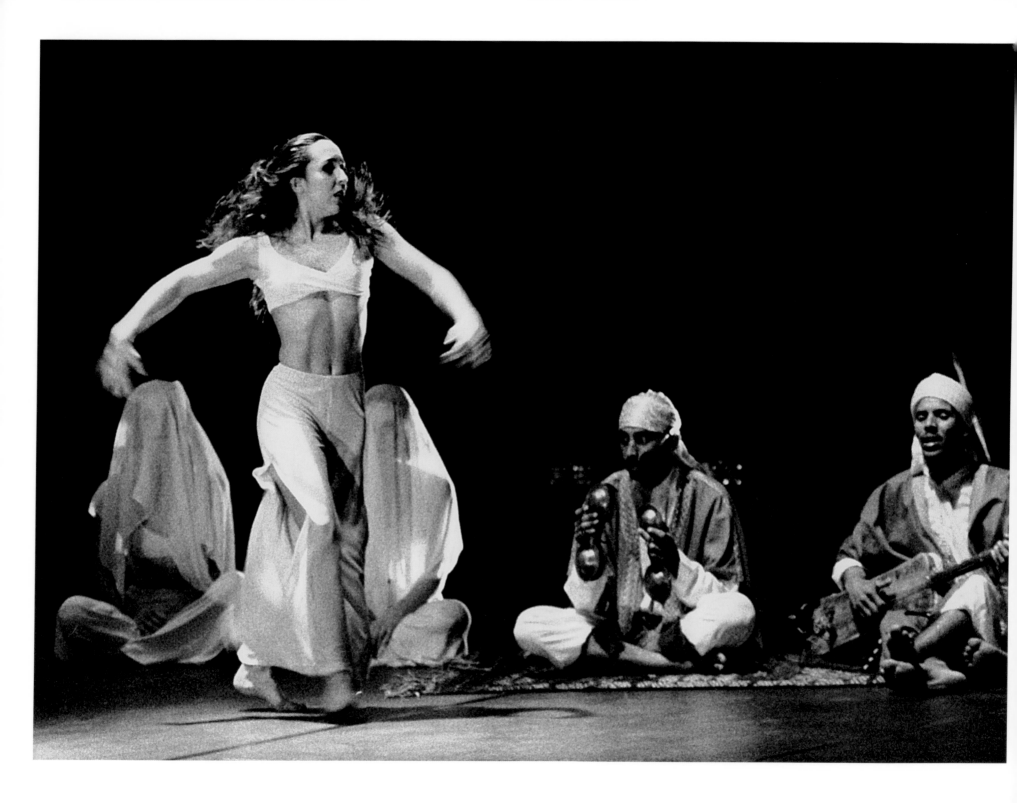

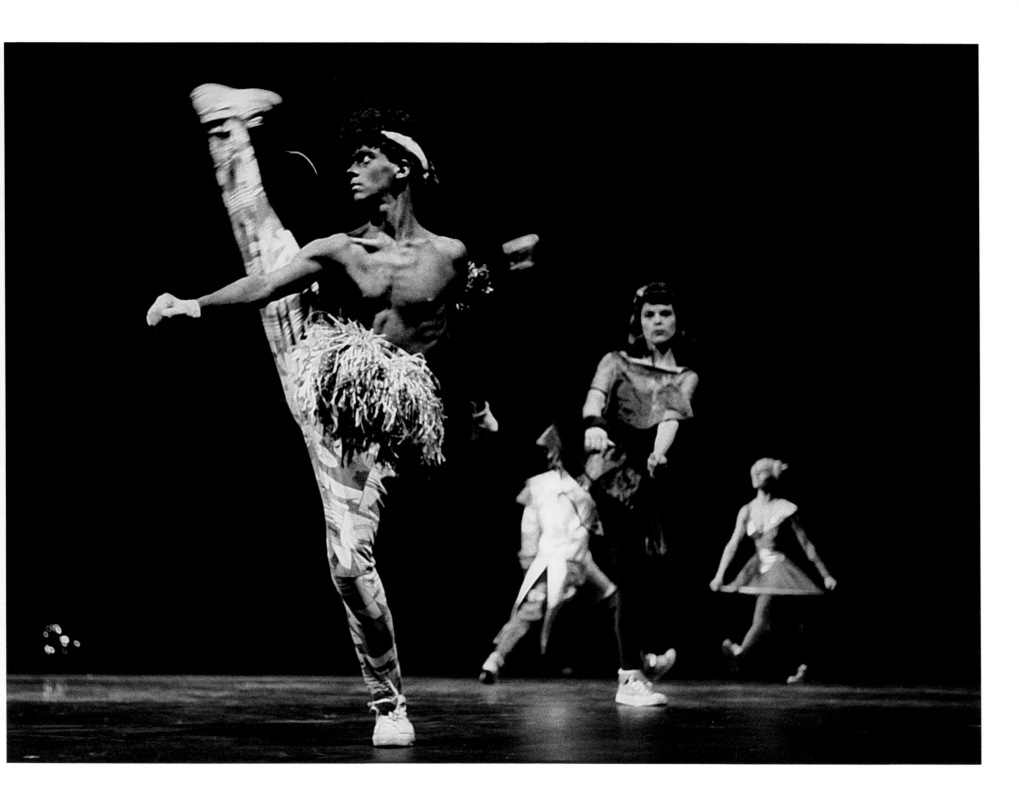

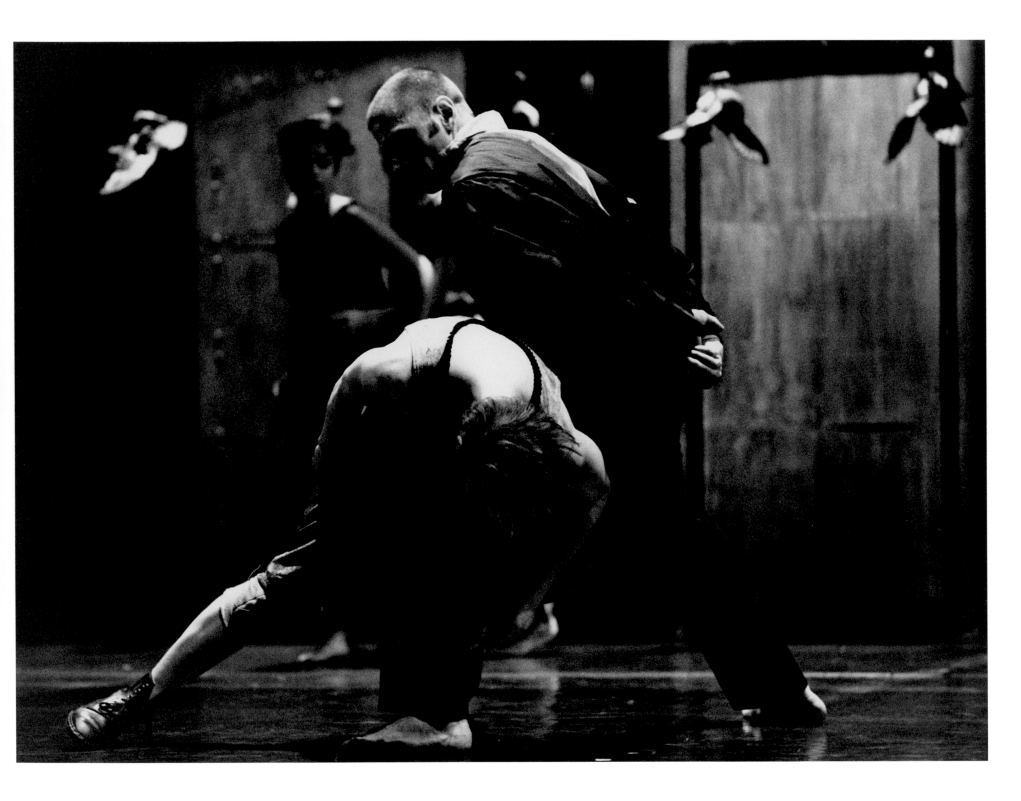

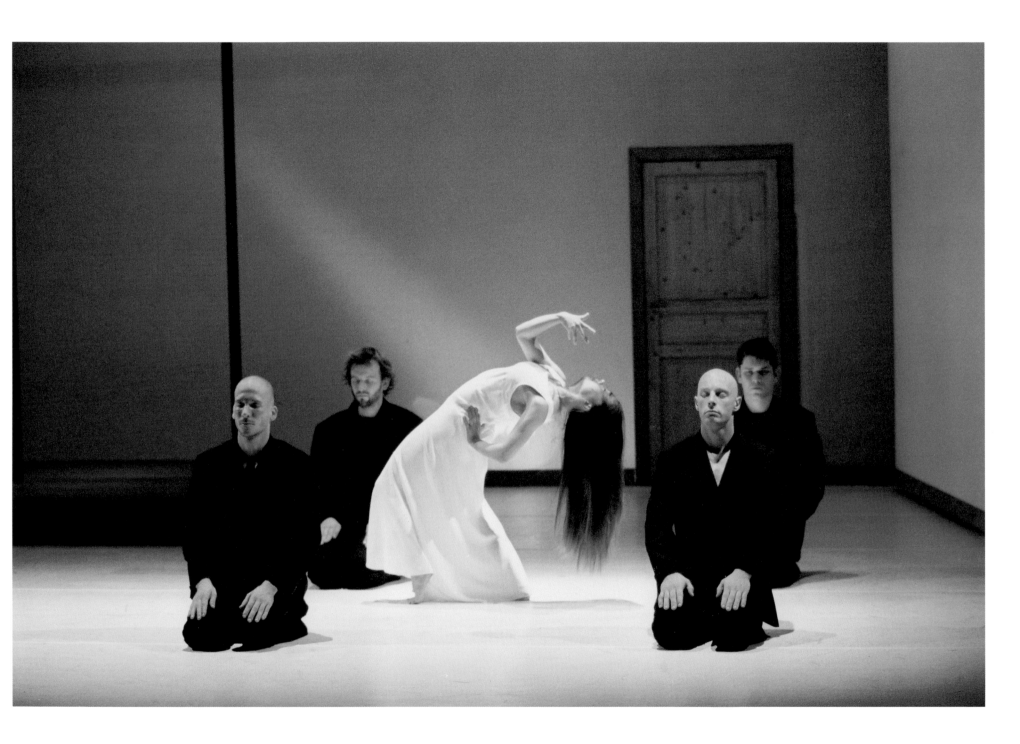

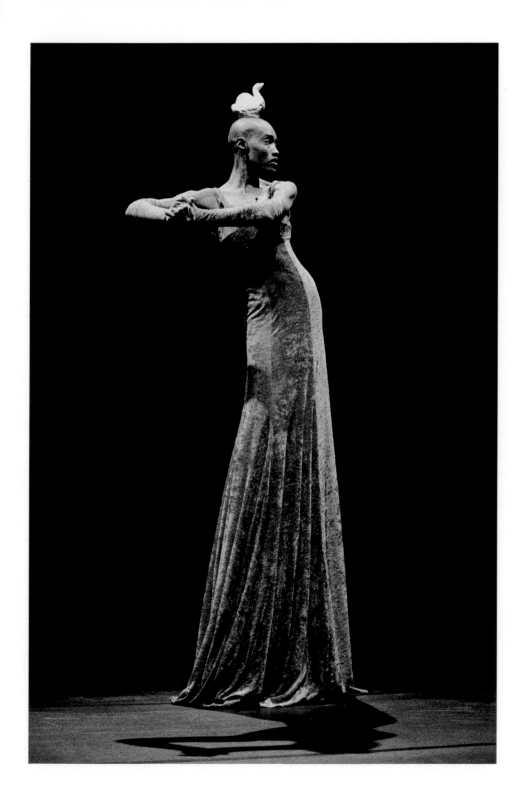

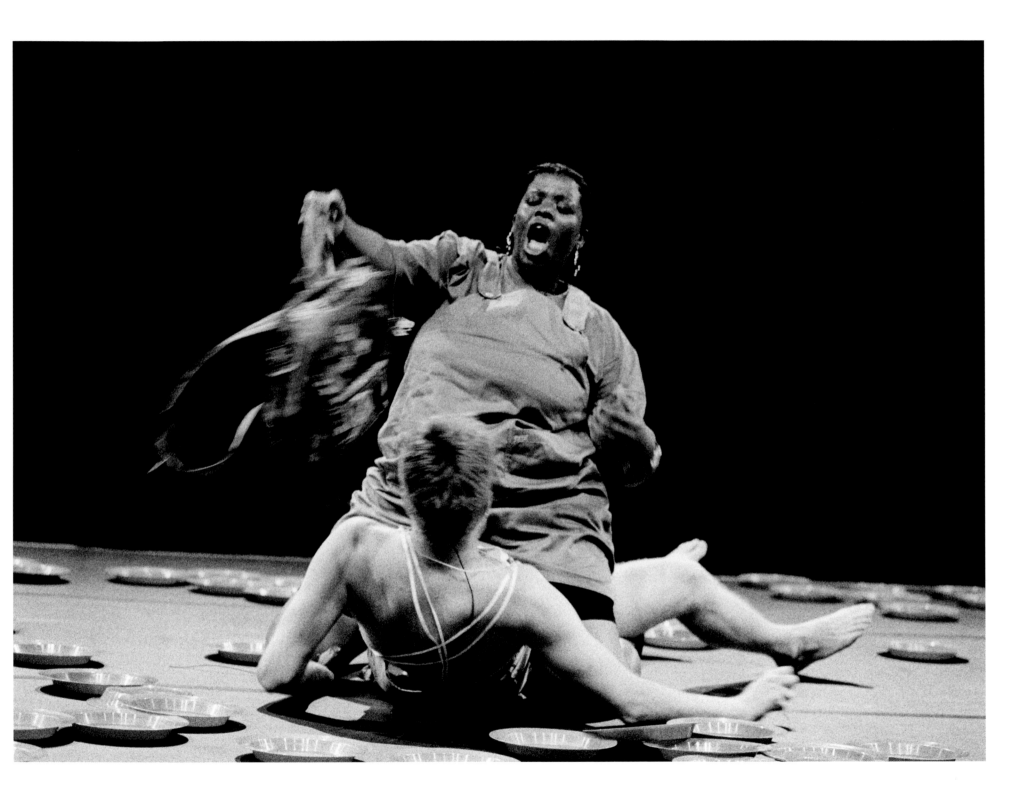

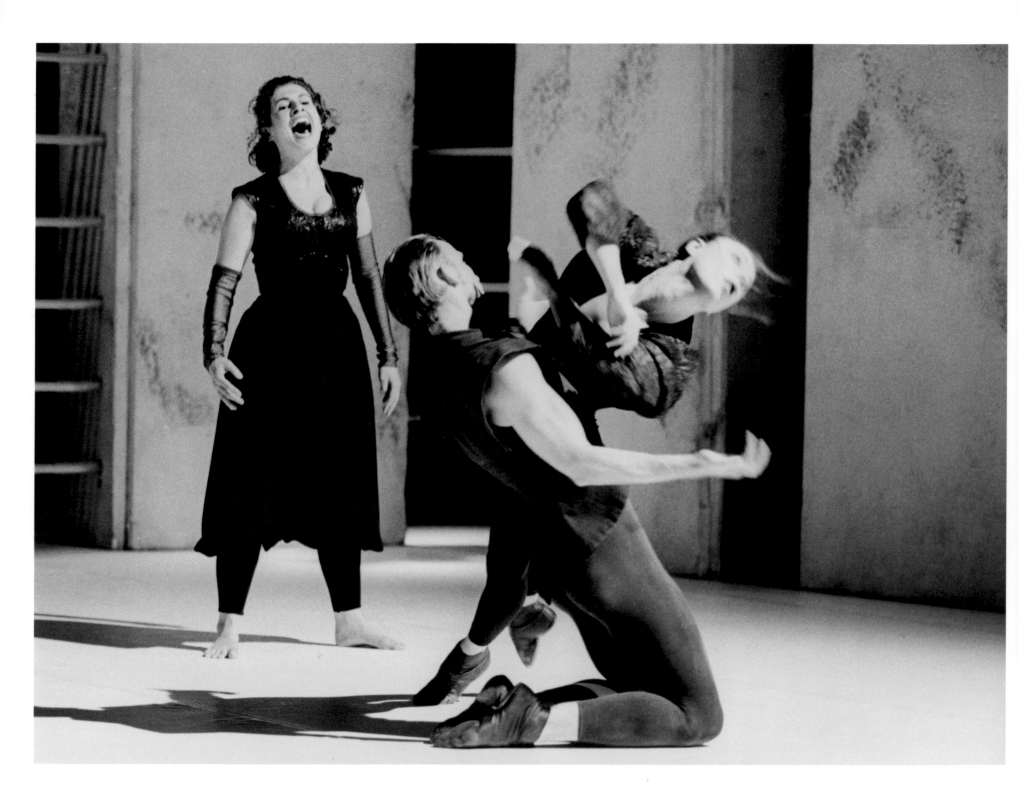

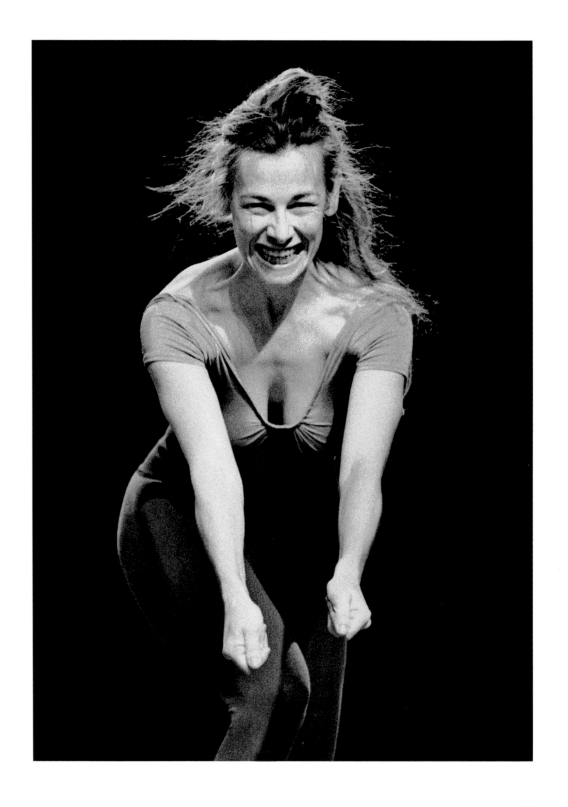

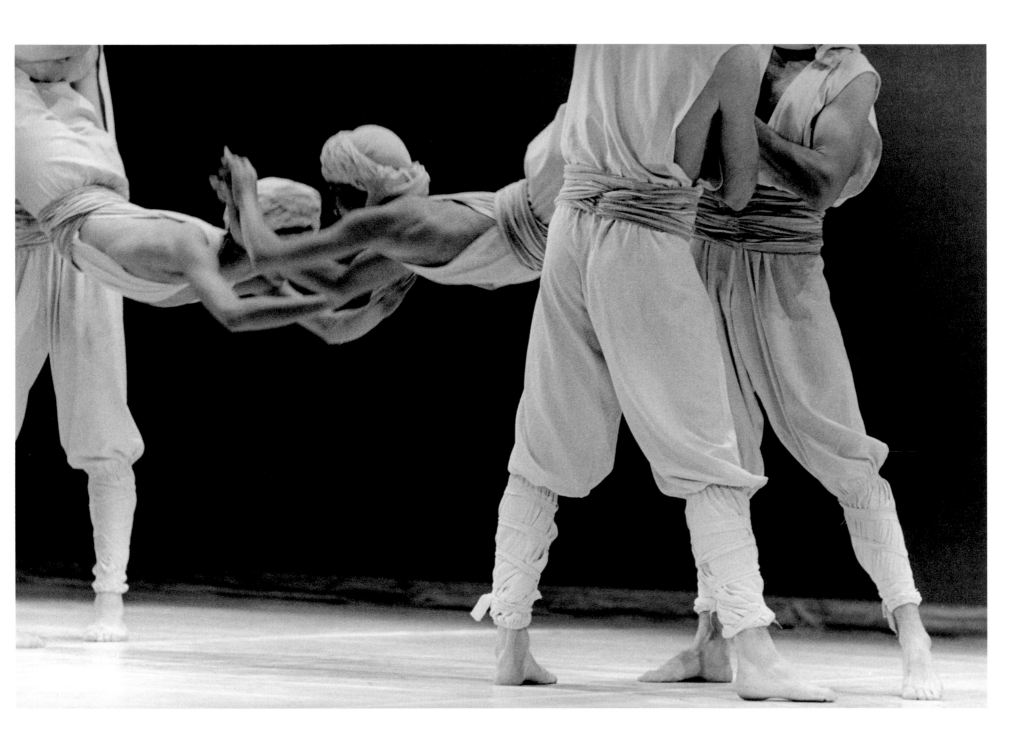

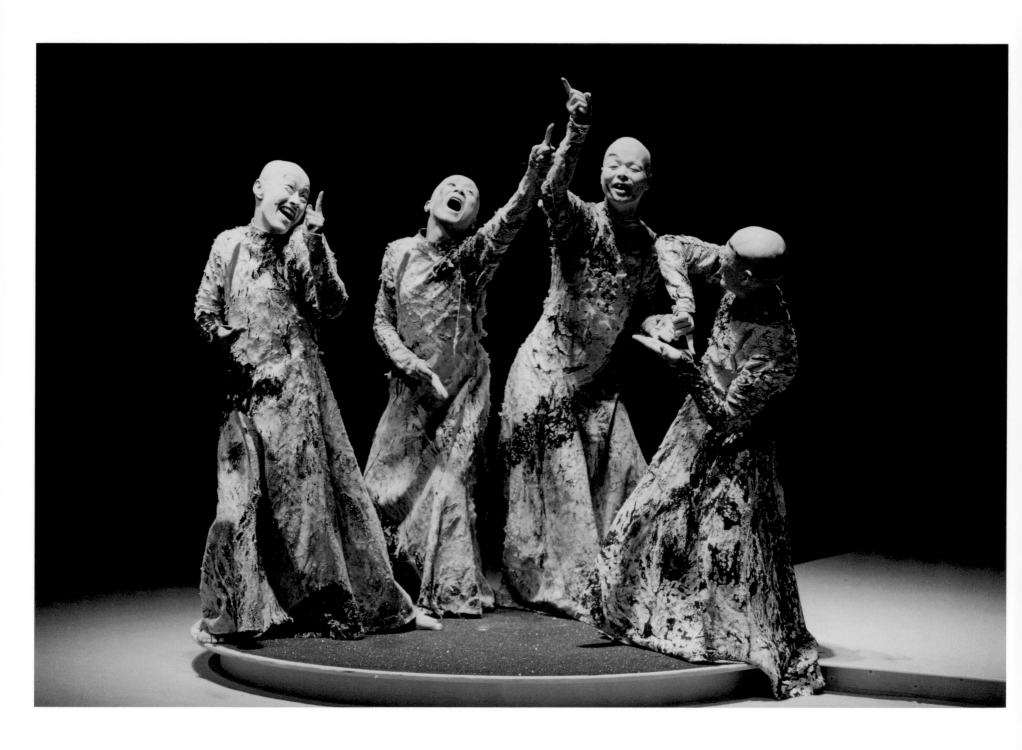

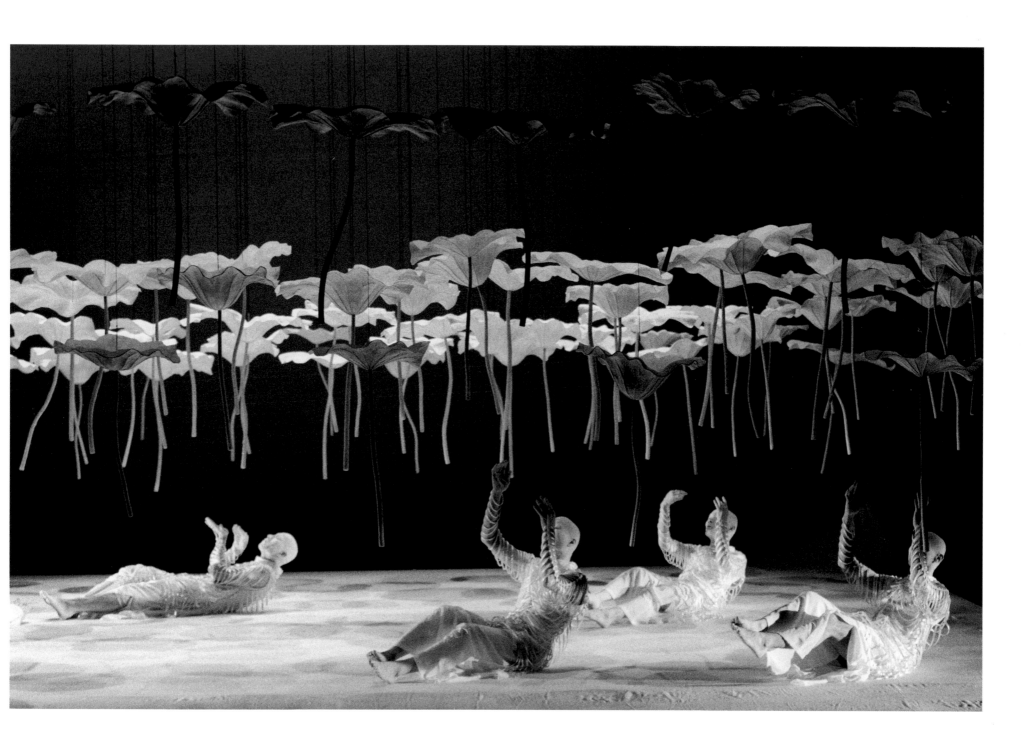

58

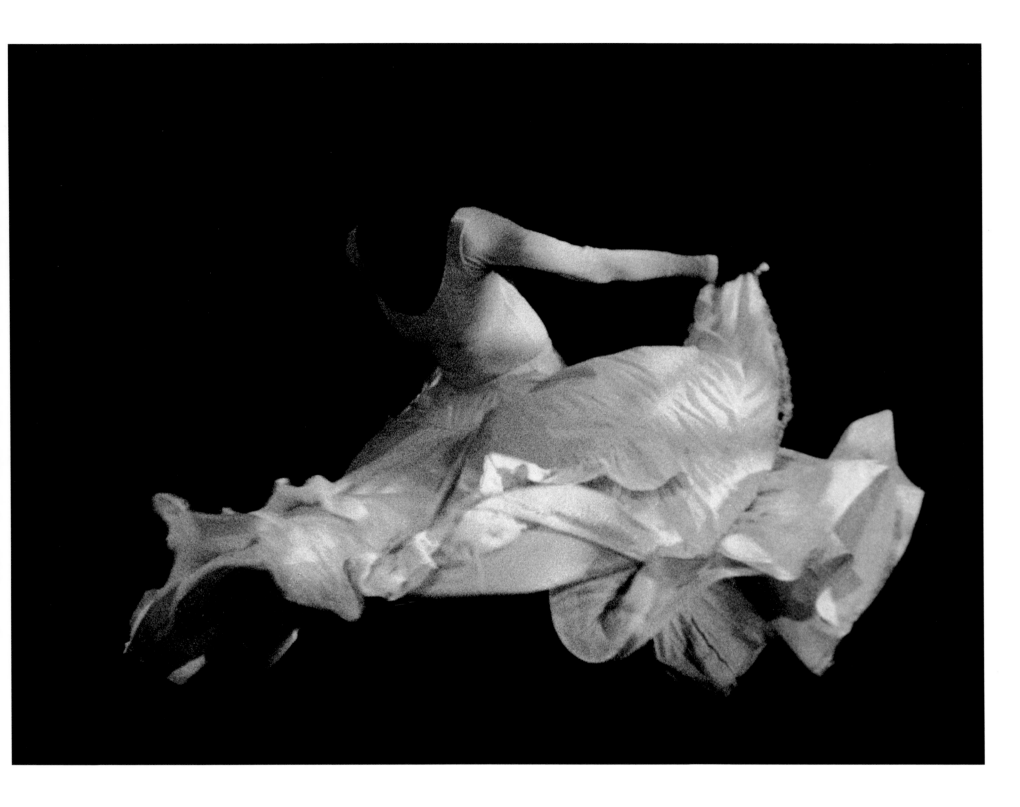

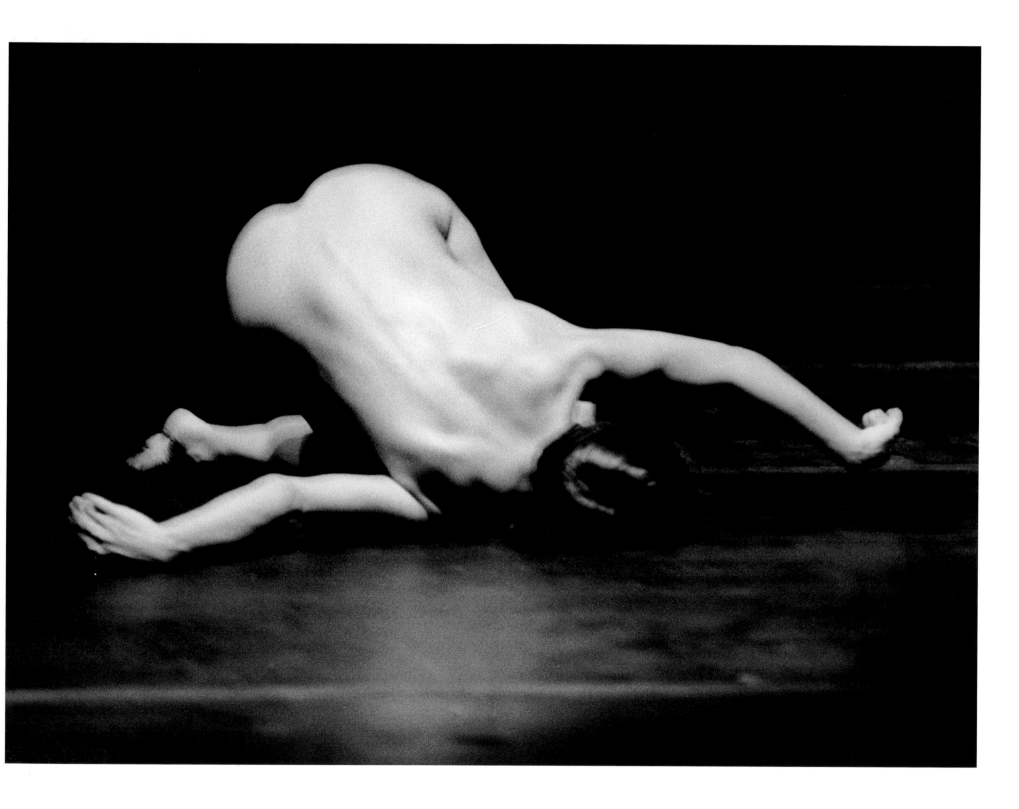

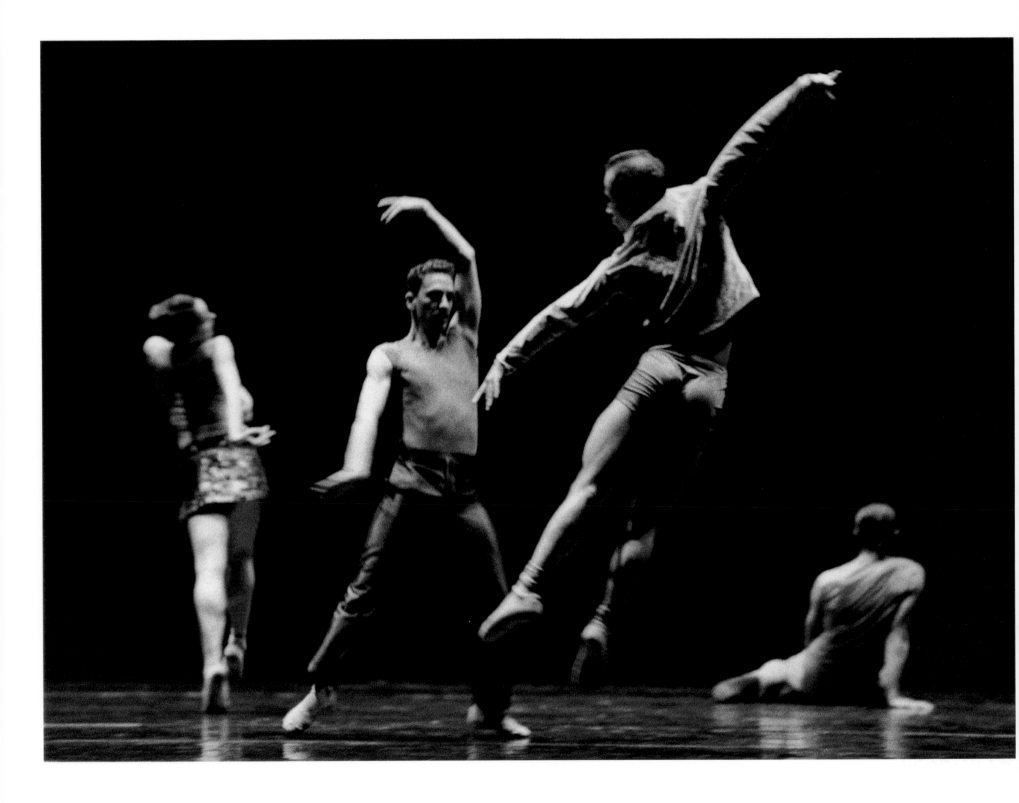

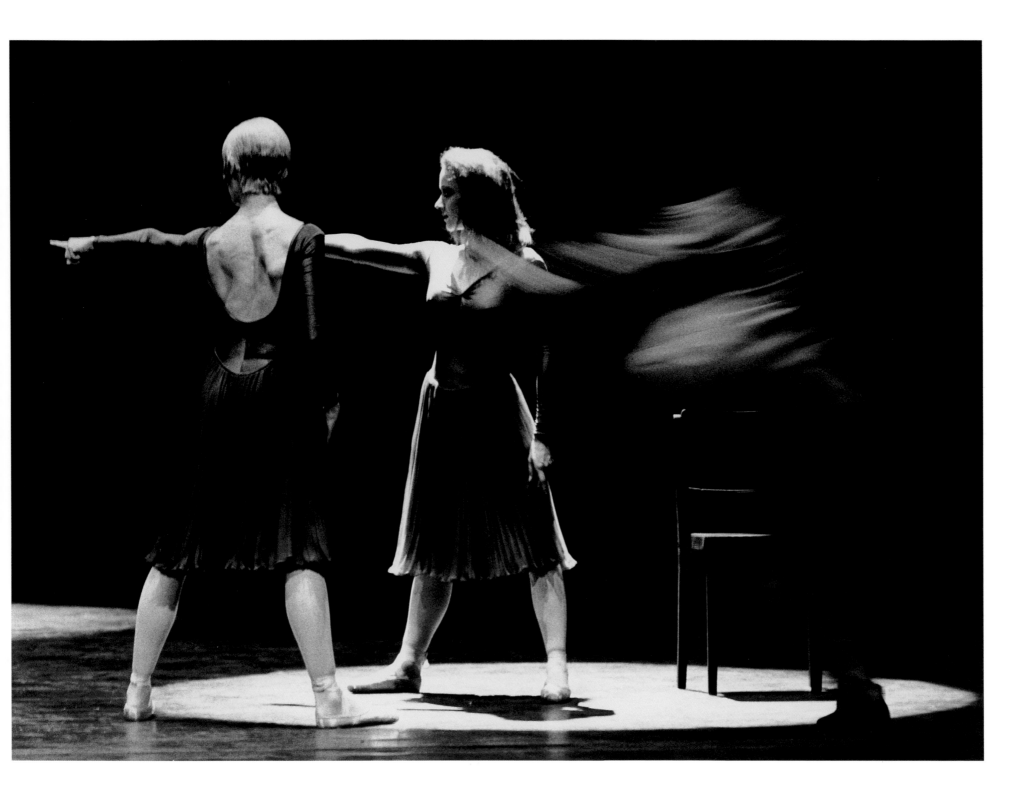

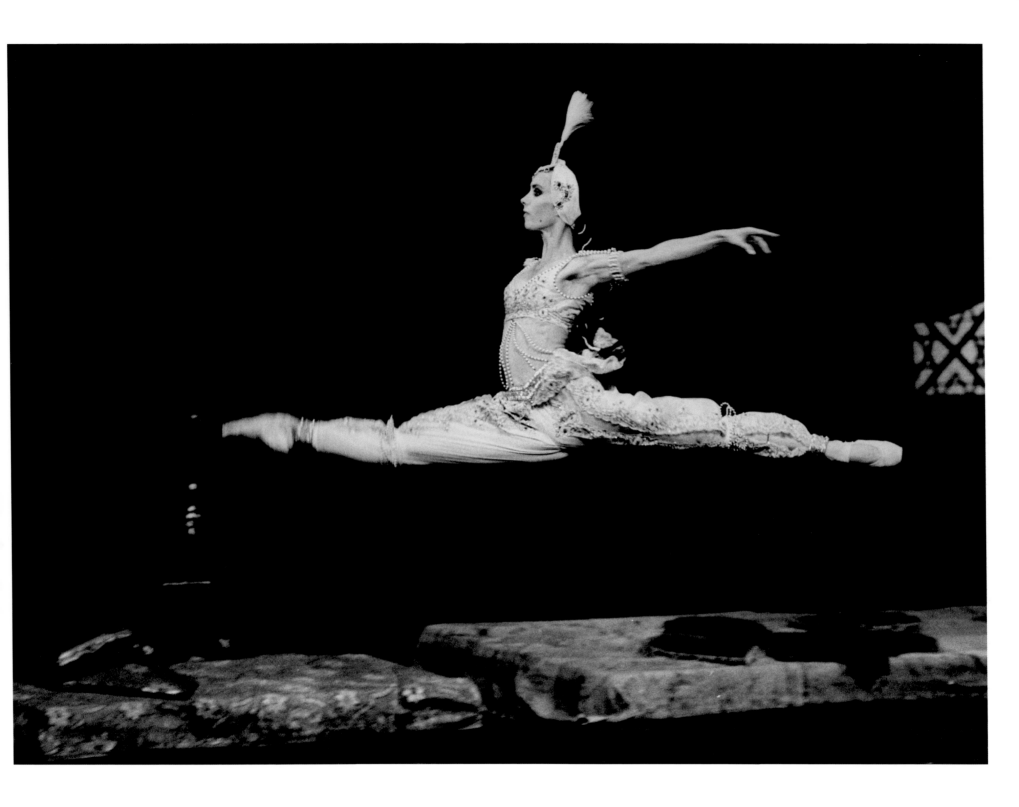

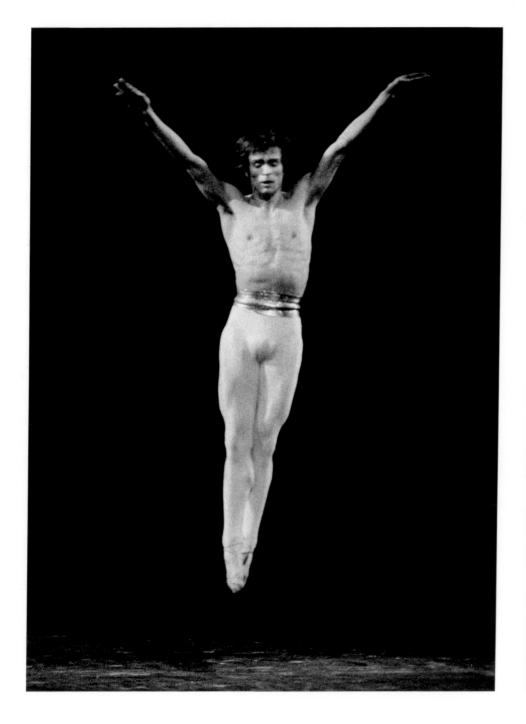

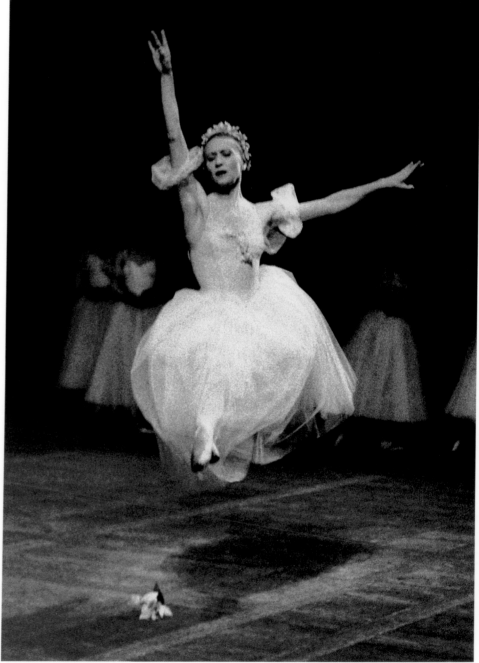

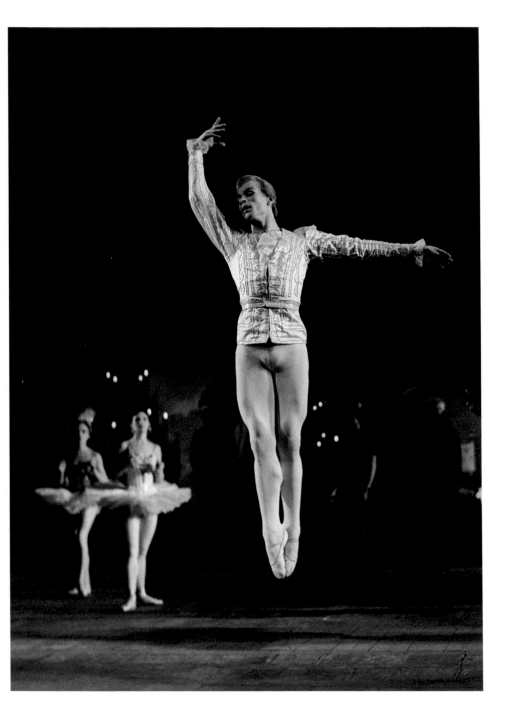

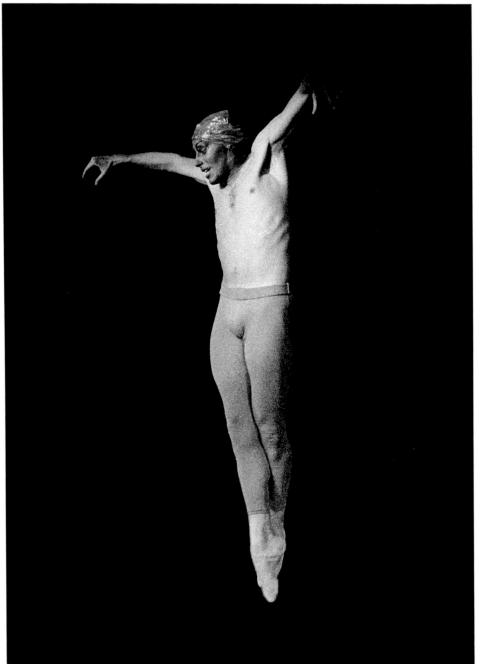

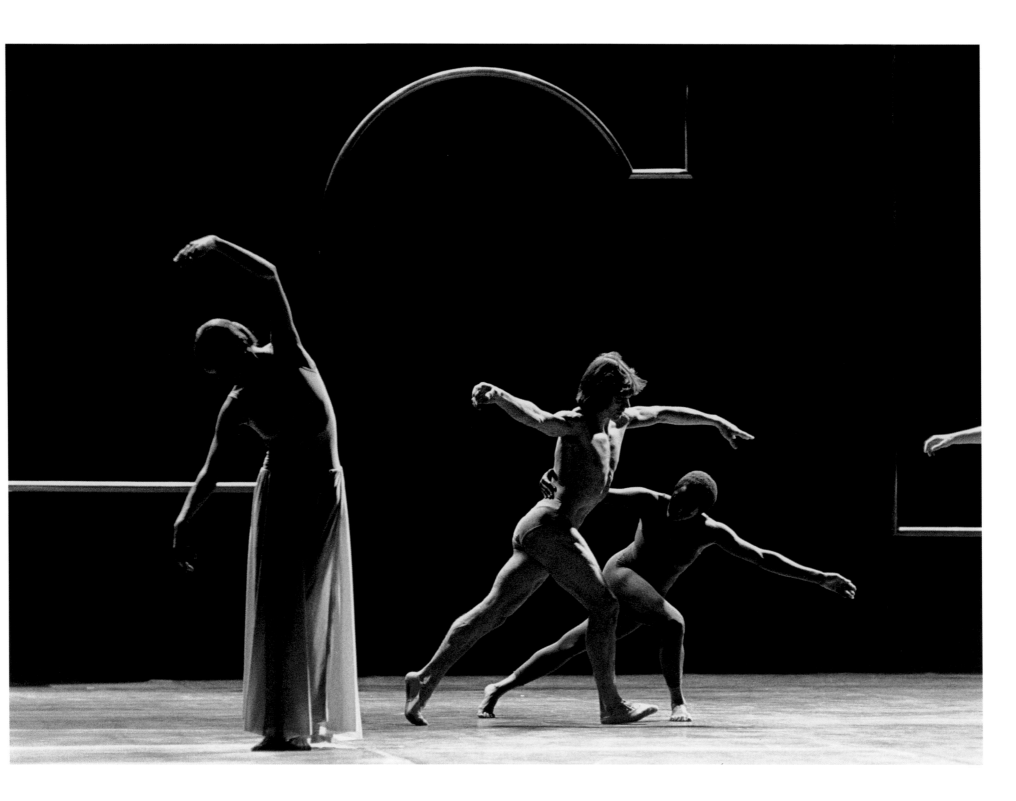

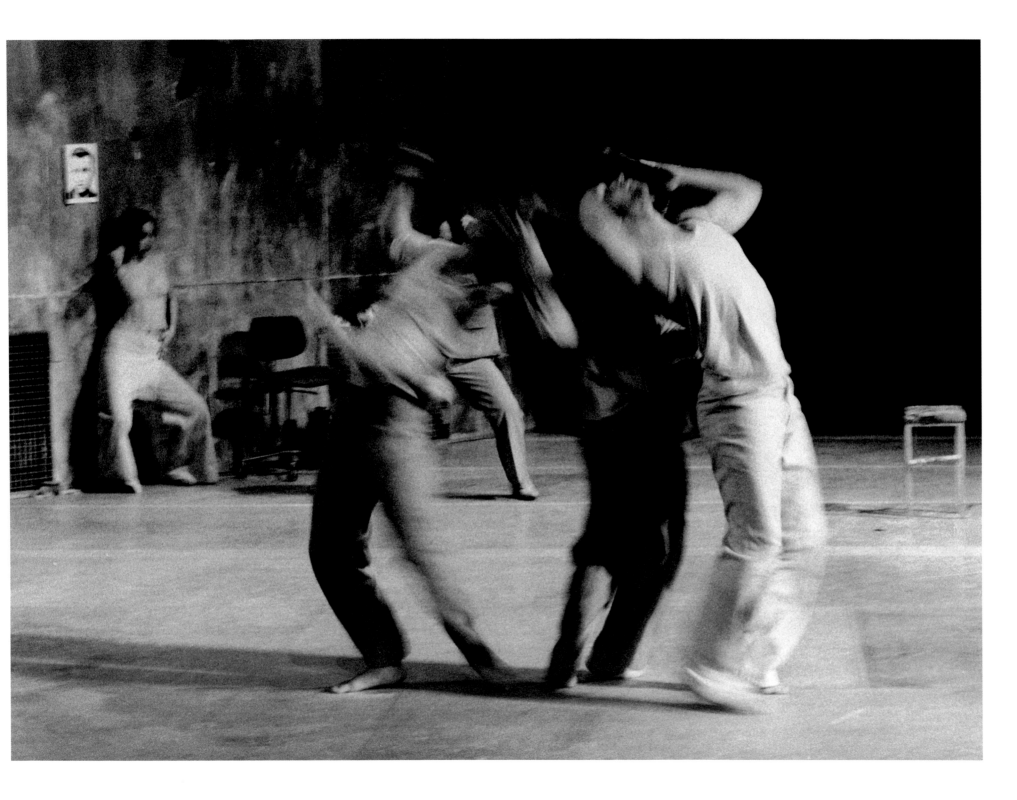

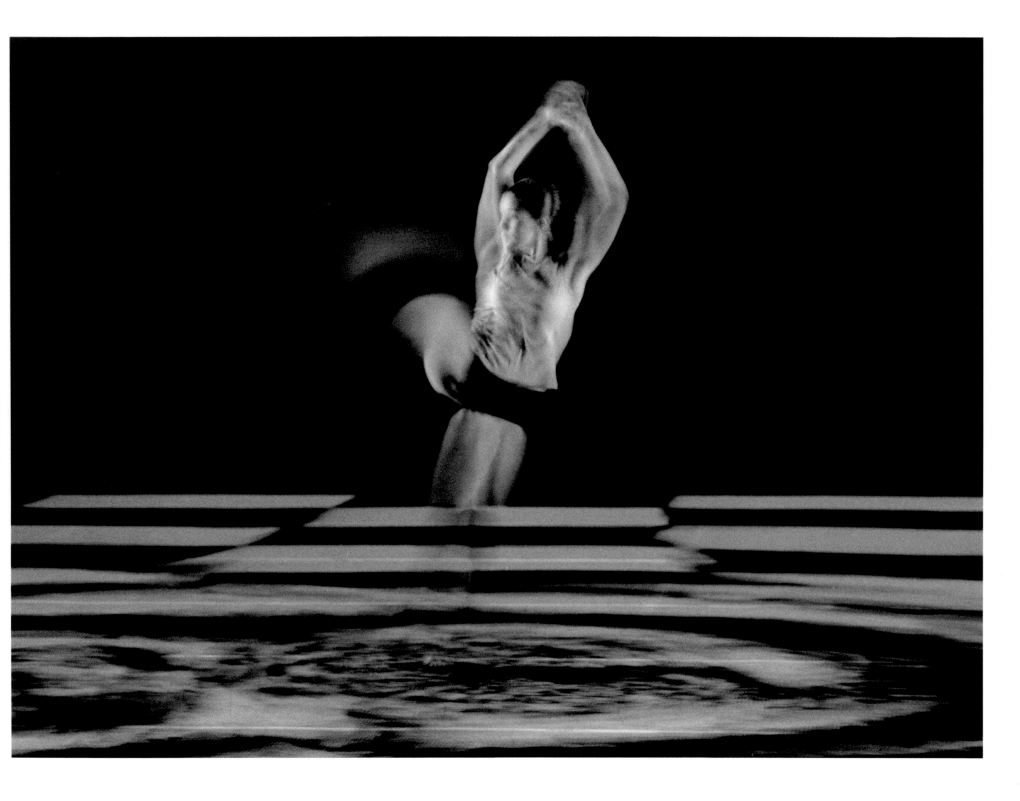

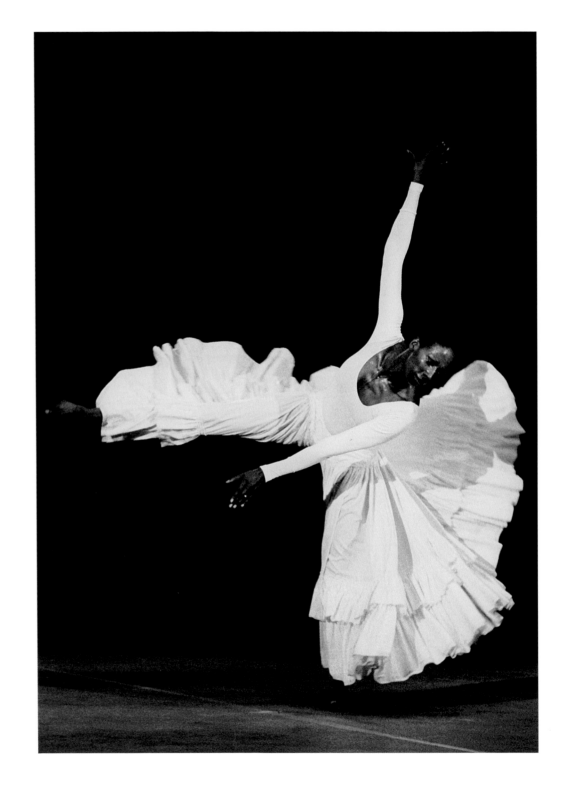

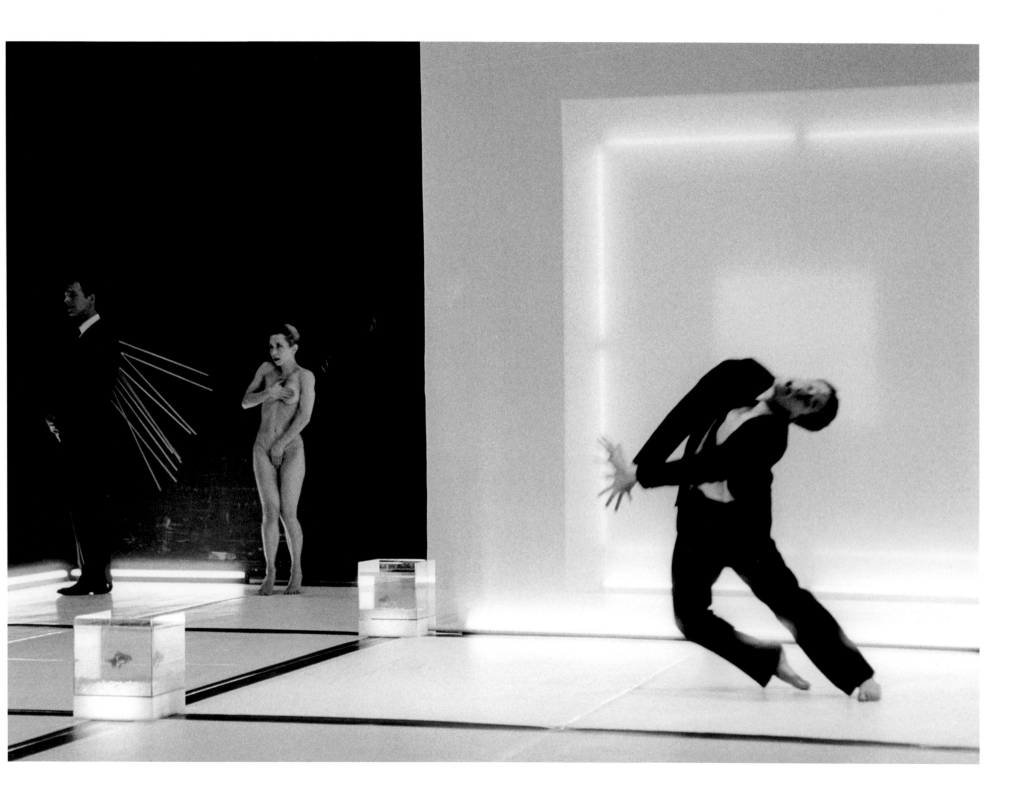

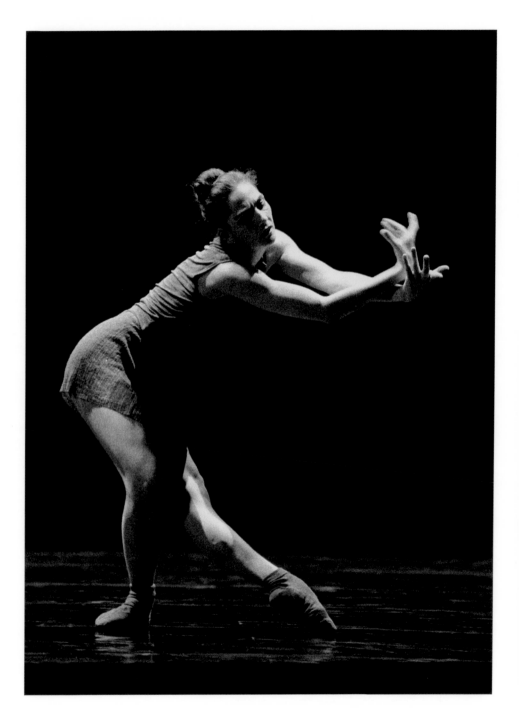
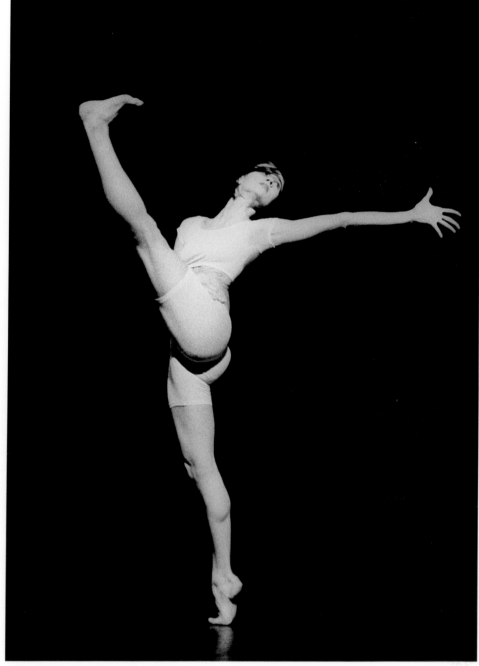

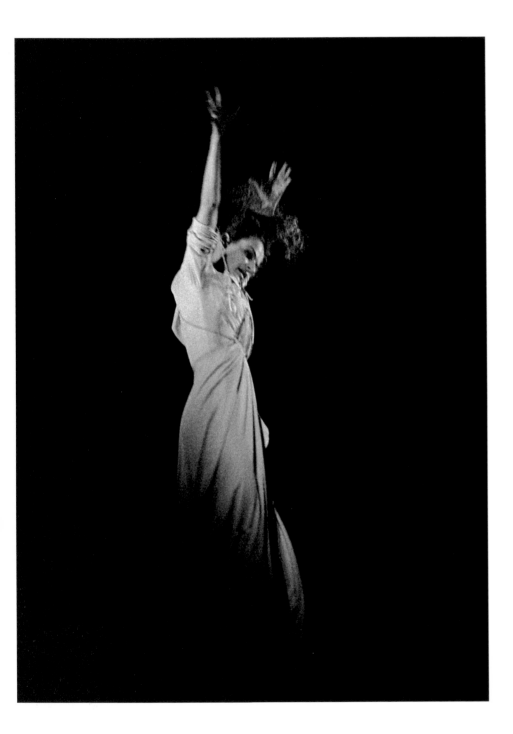
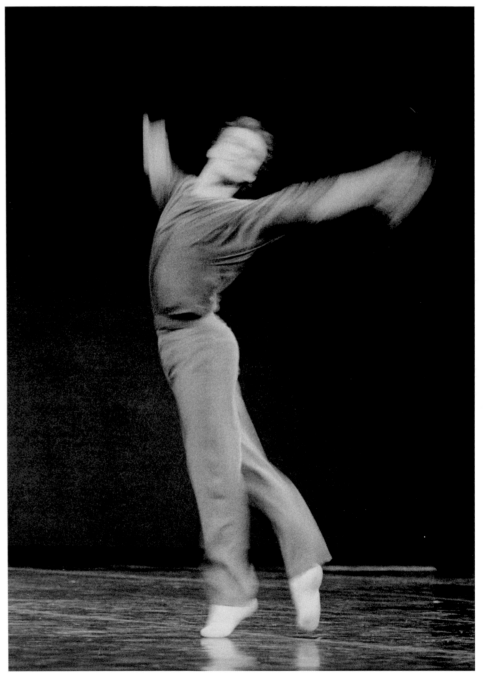

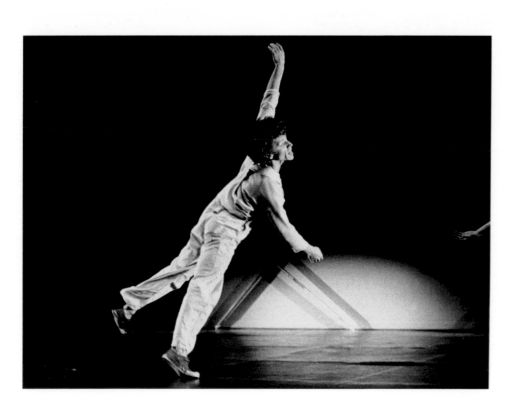
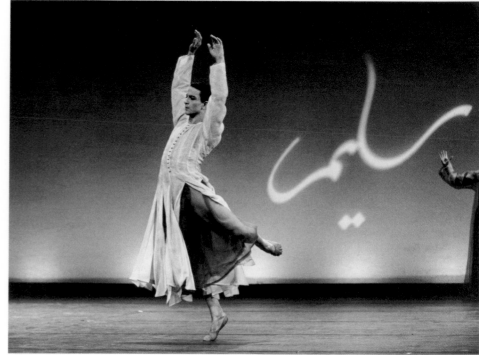

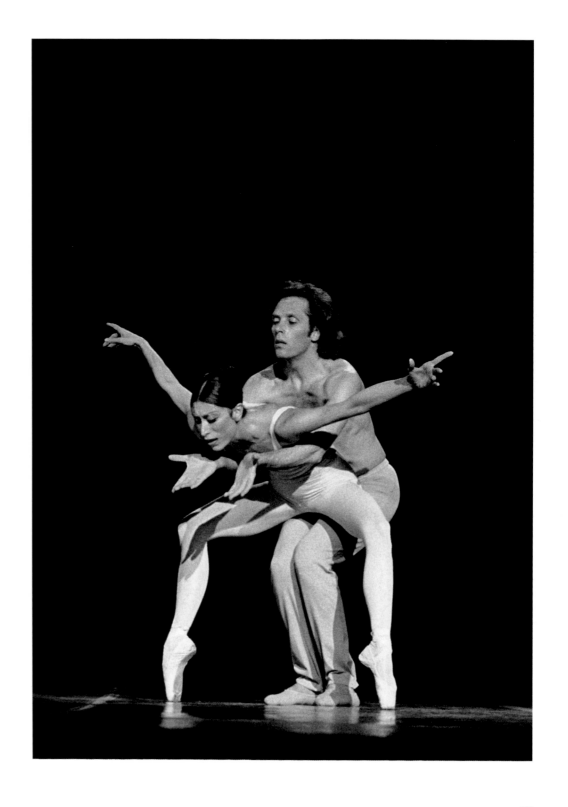

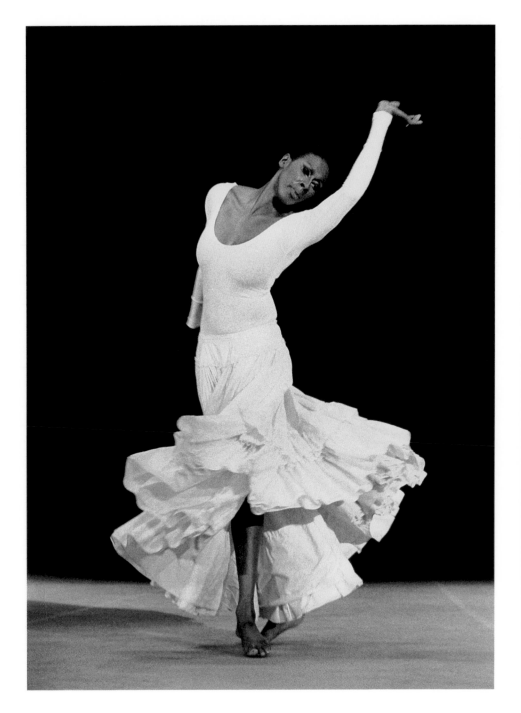

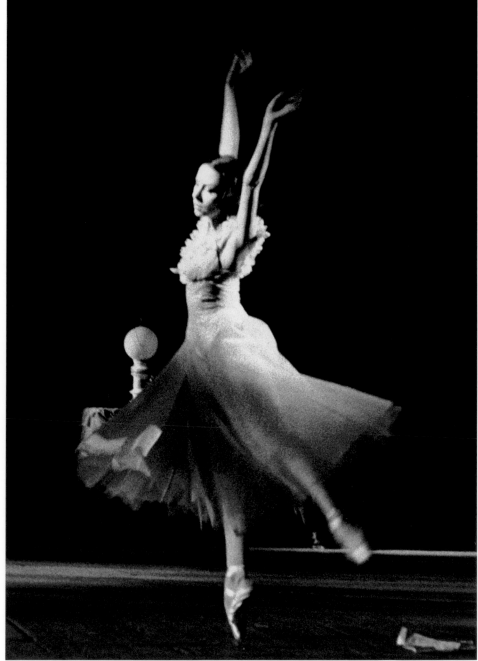

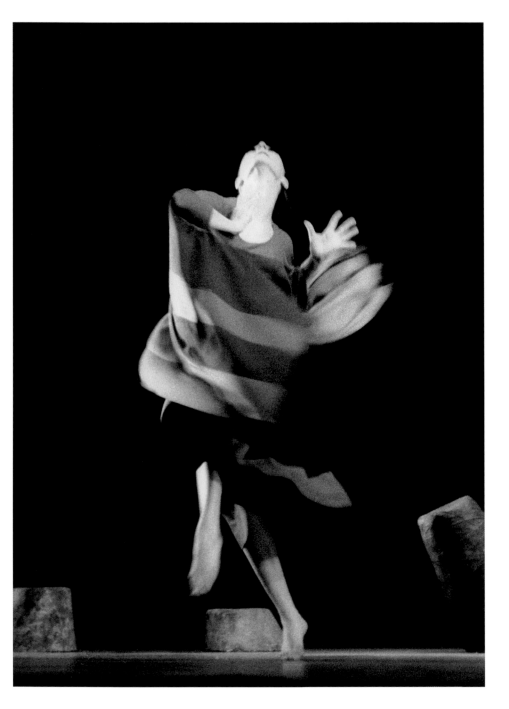

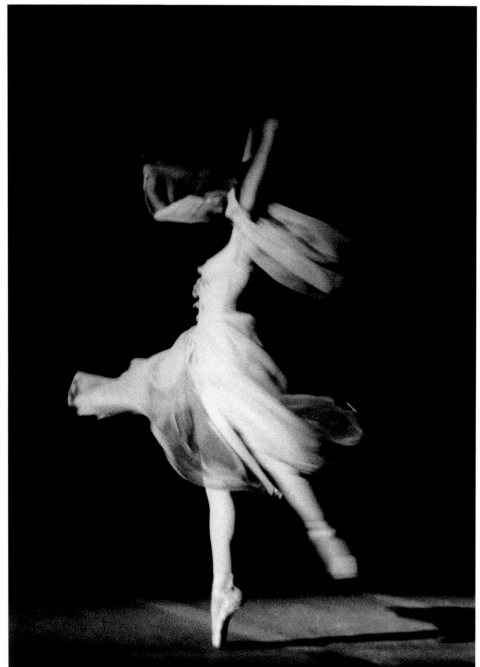

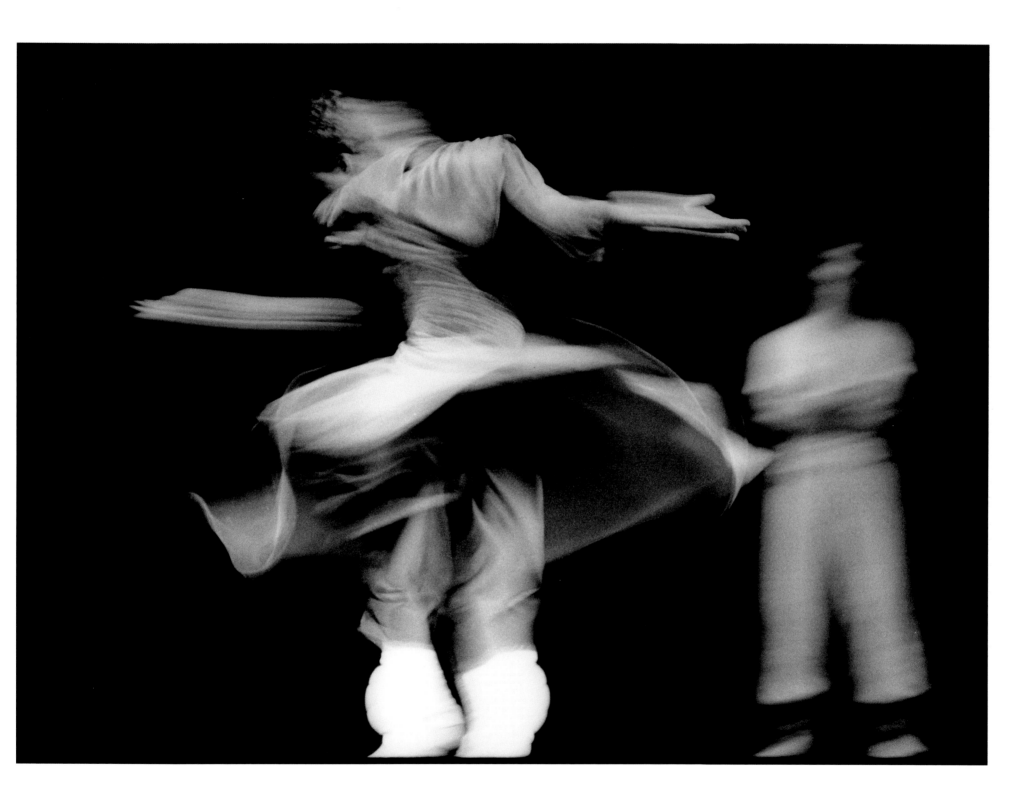

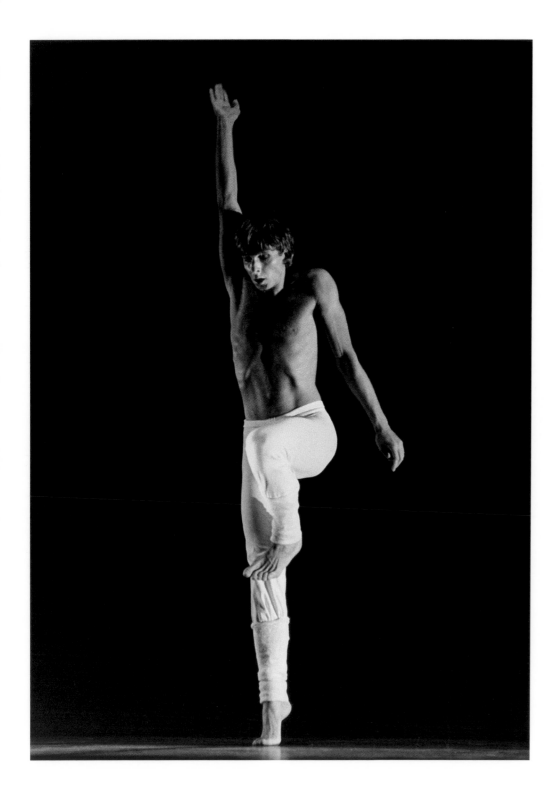

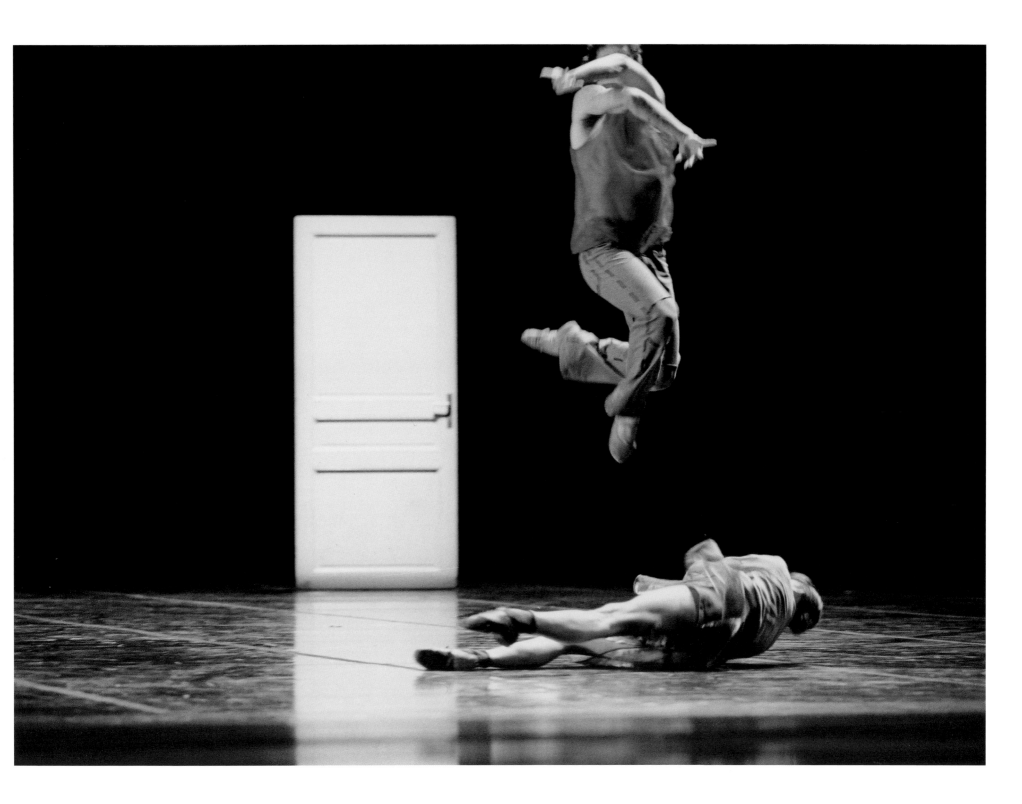

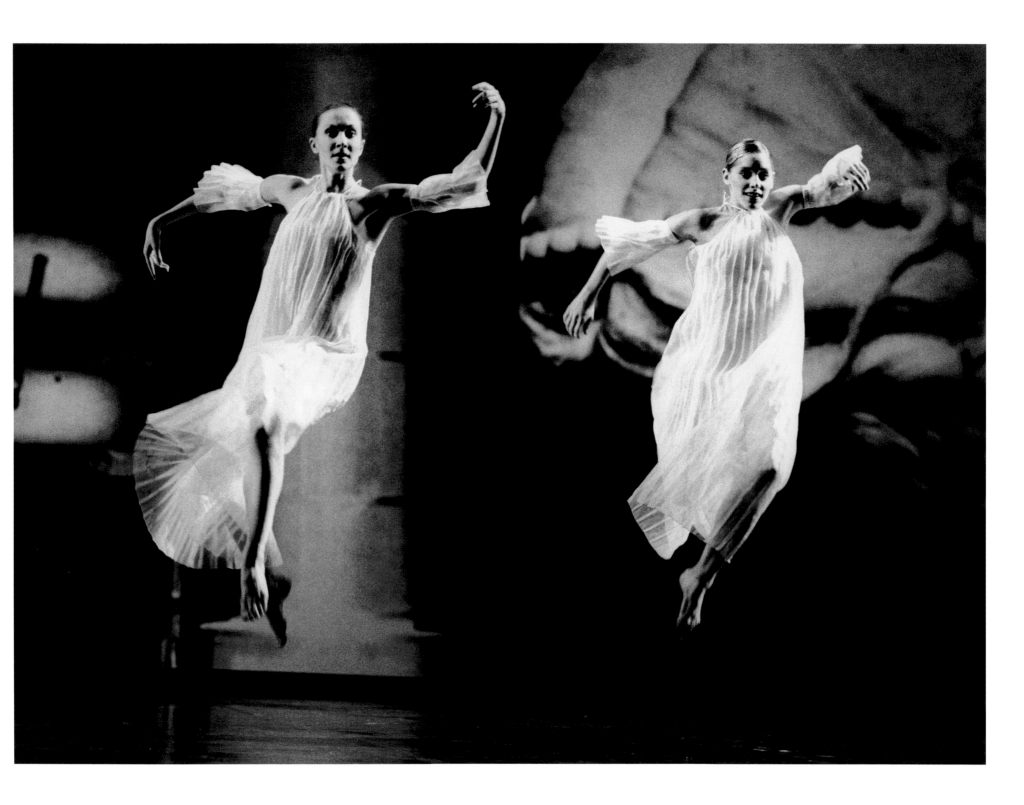

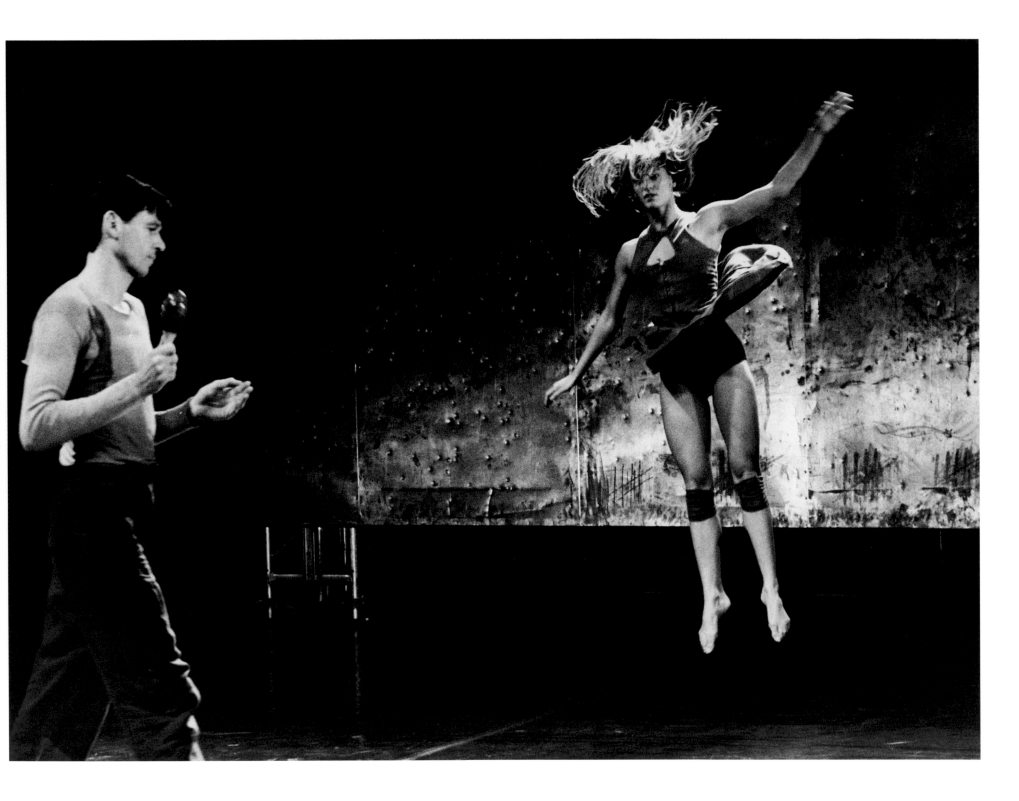

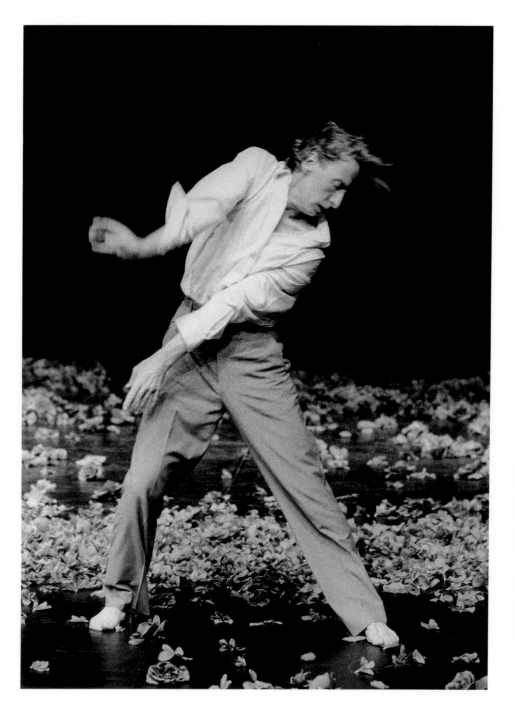
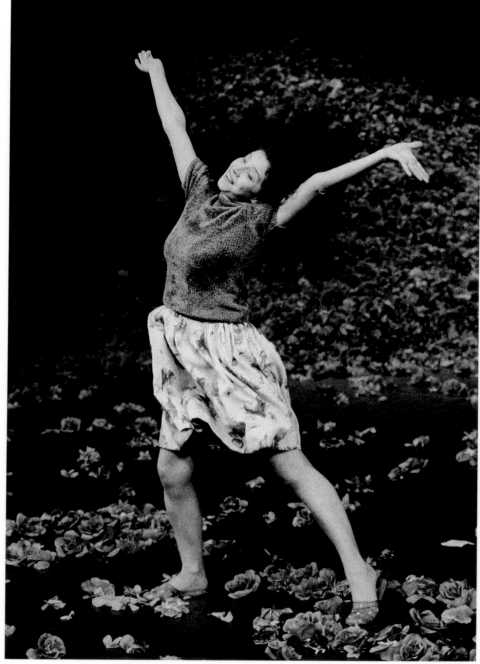

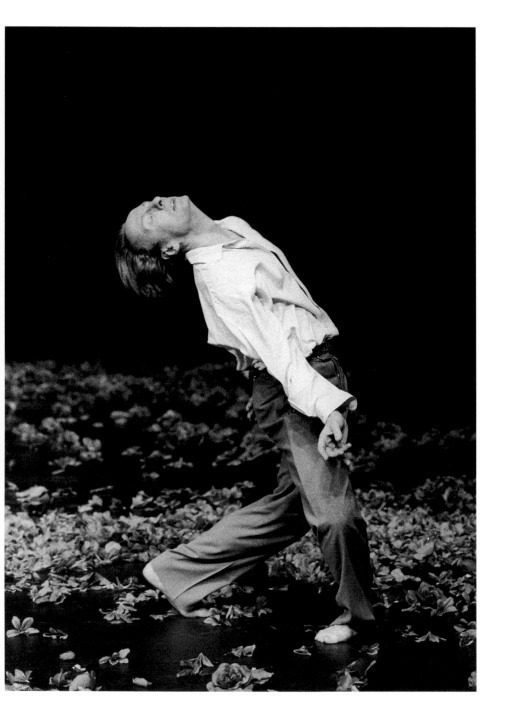
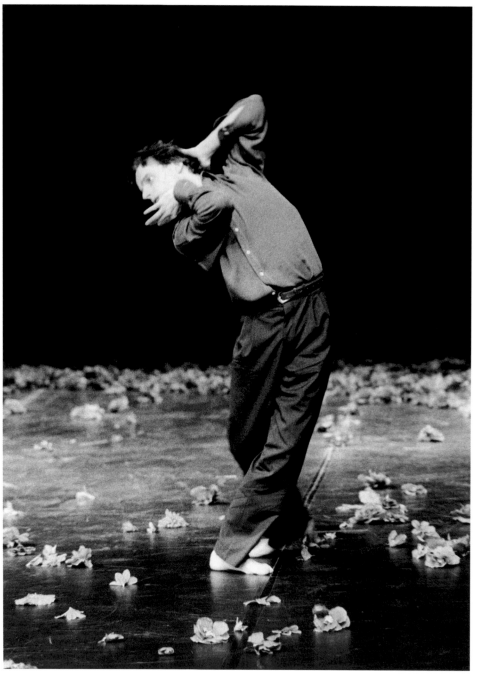

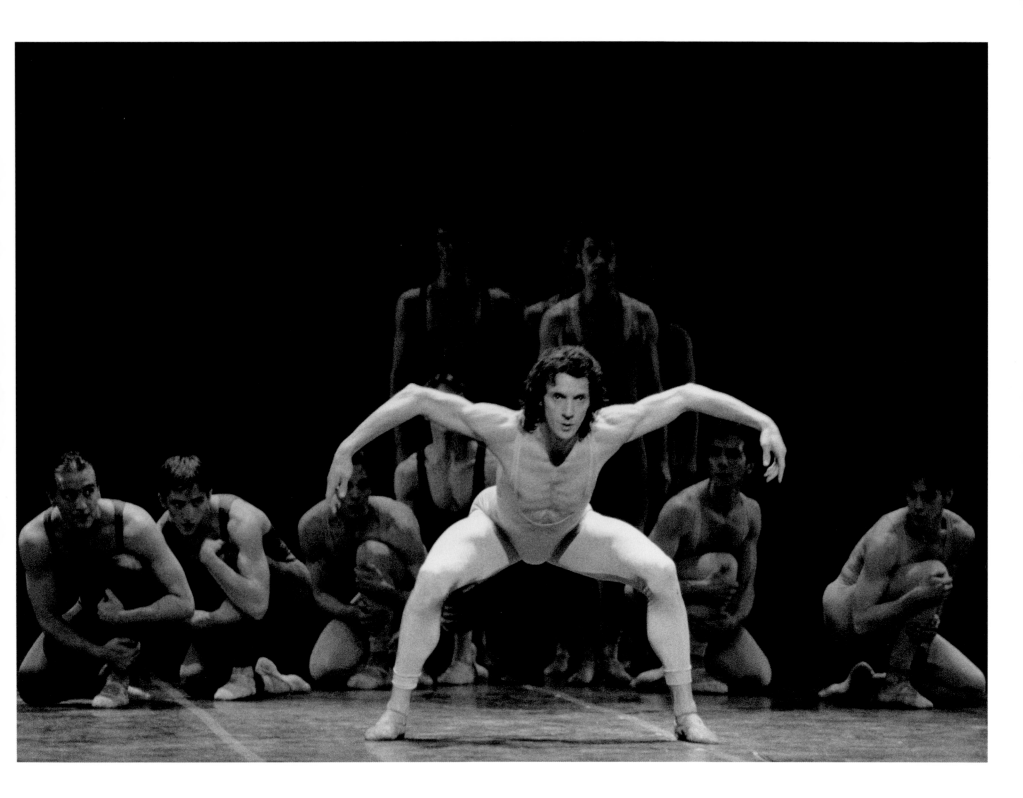

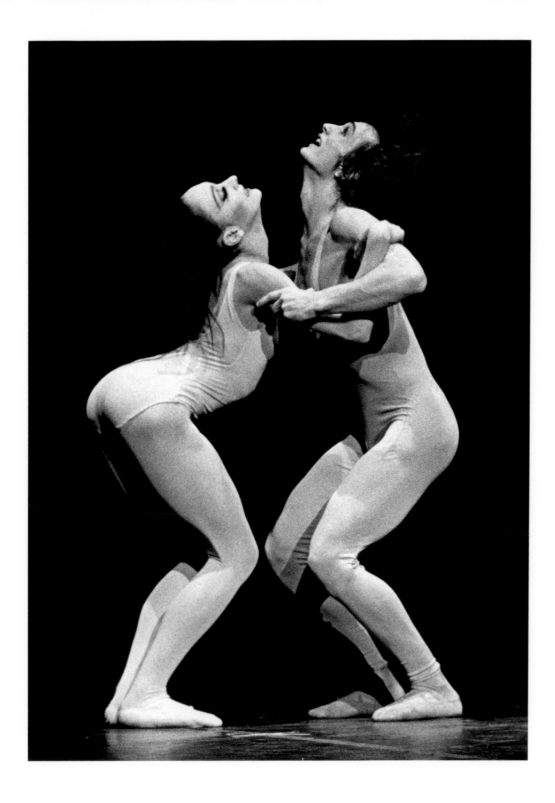

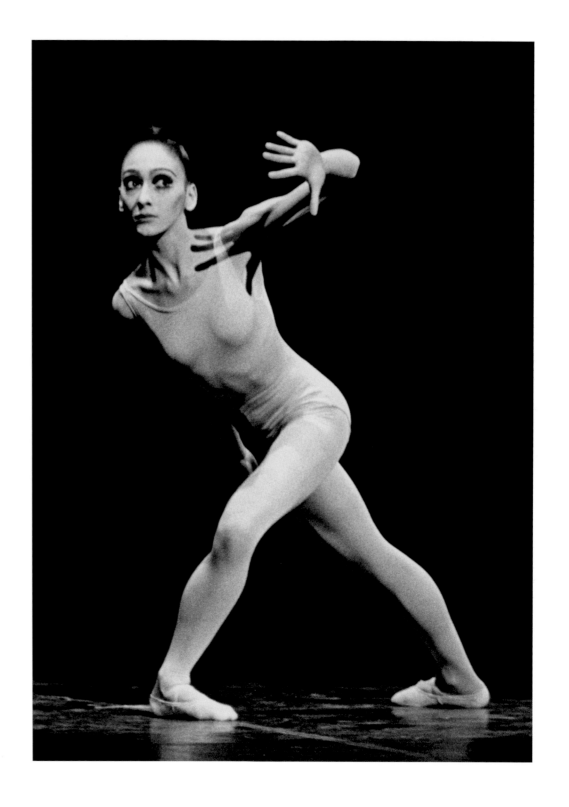

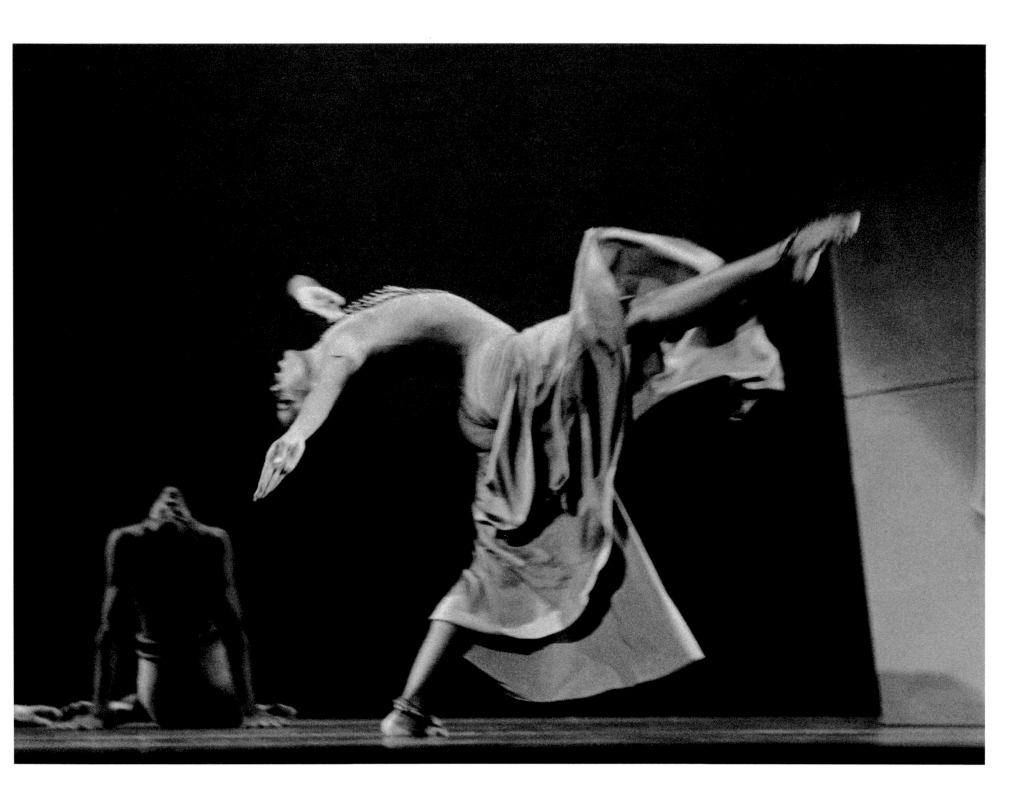

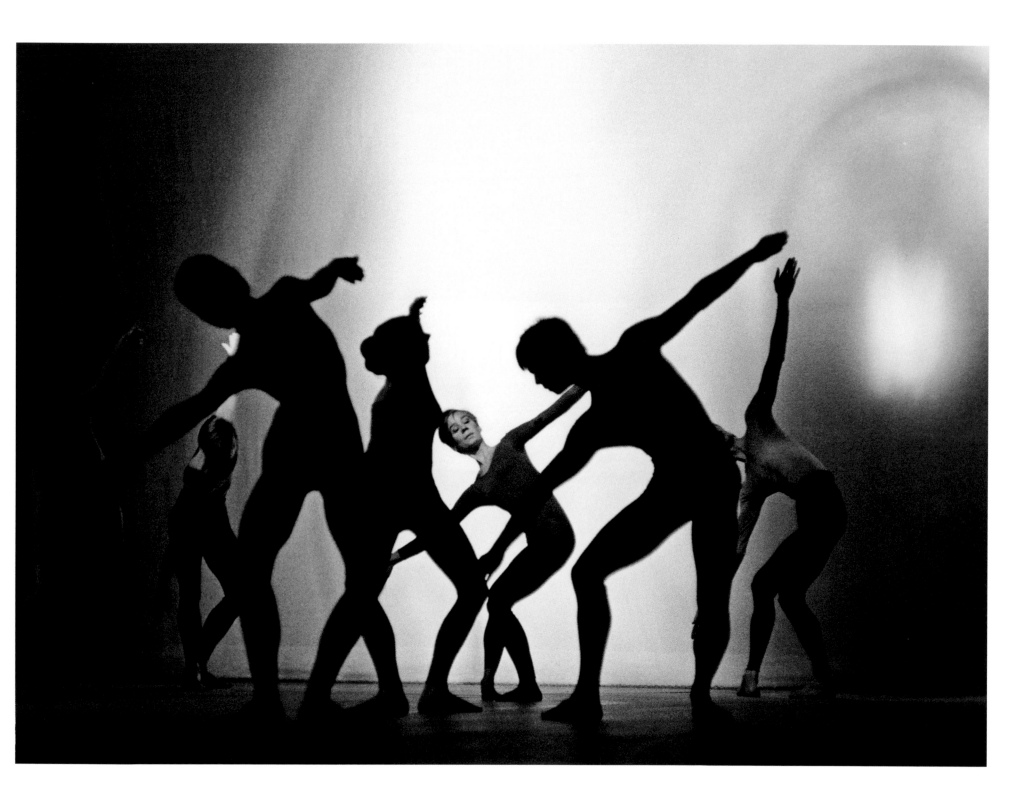

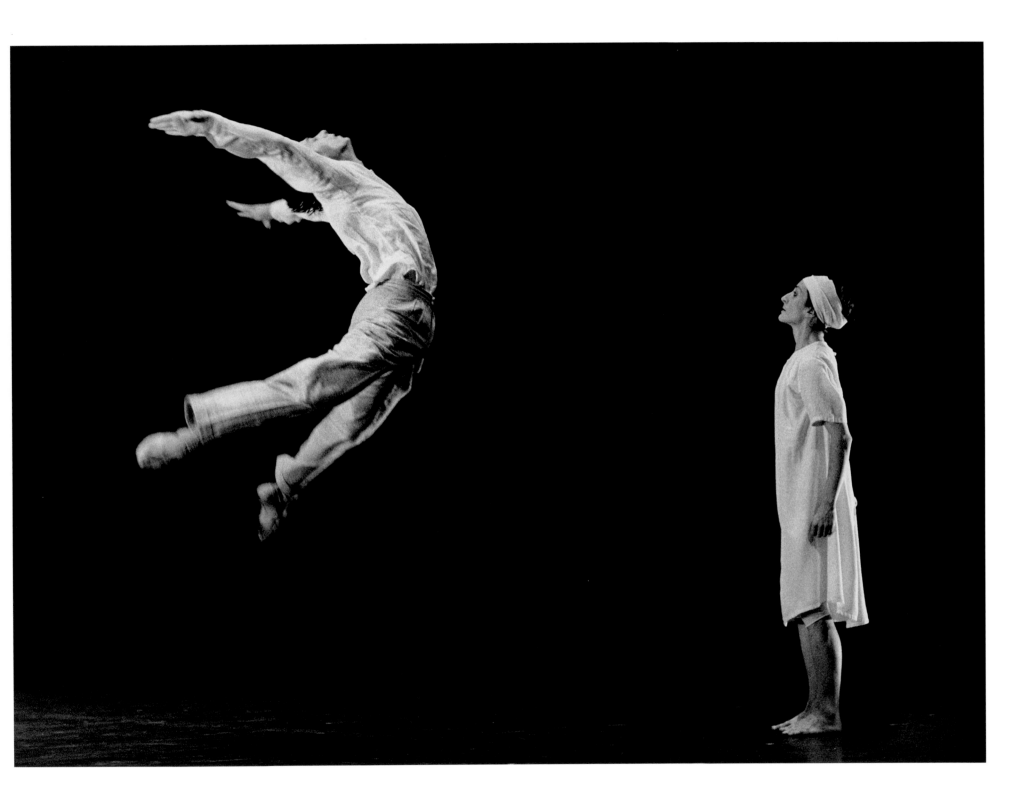

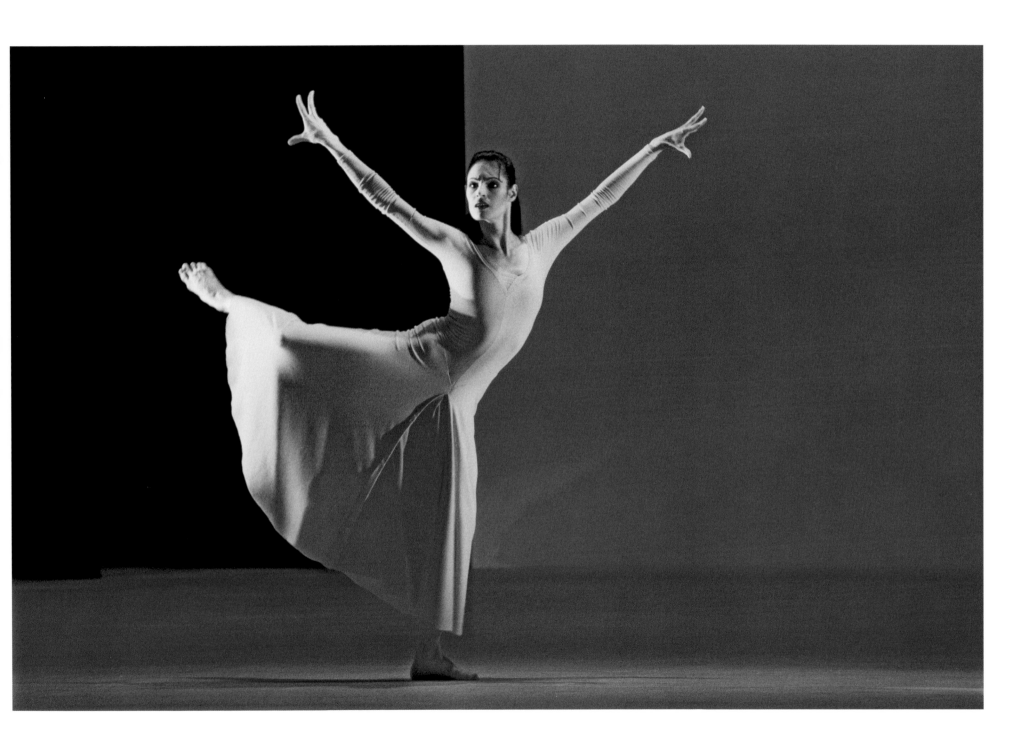

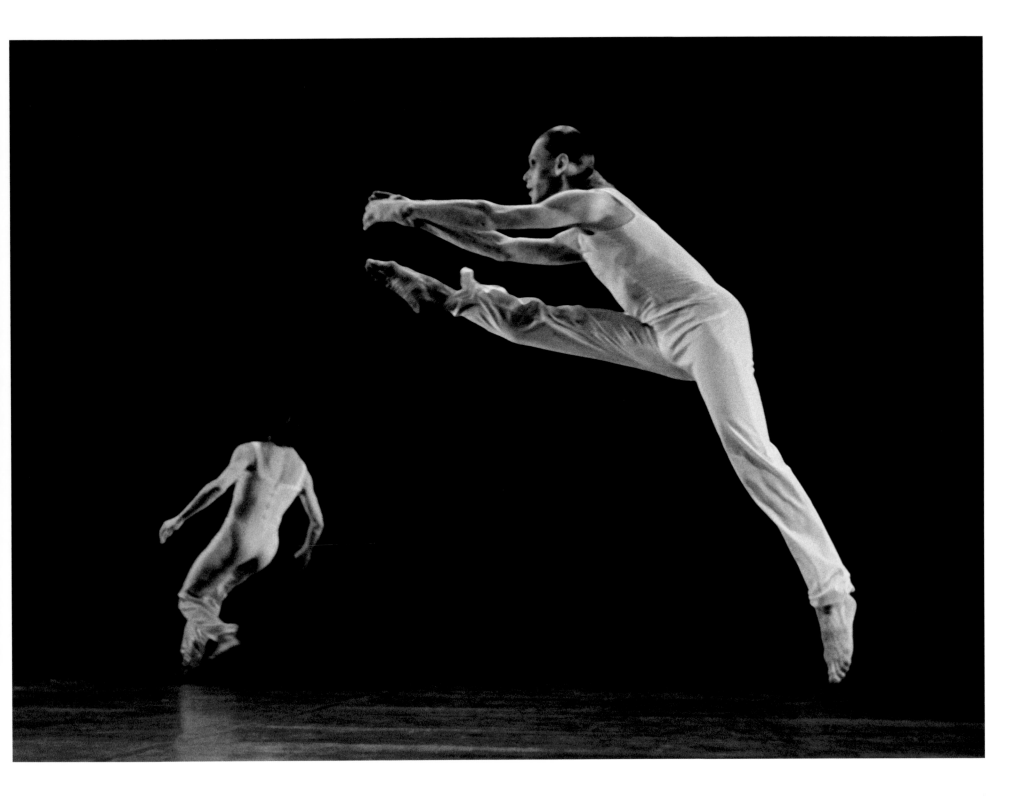

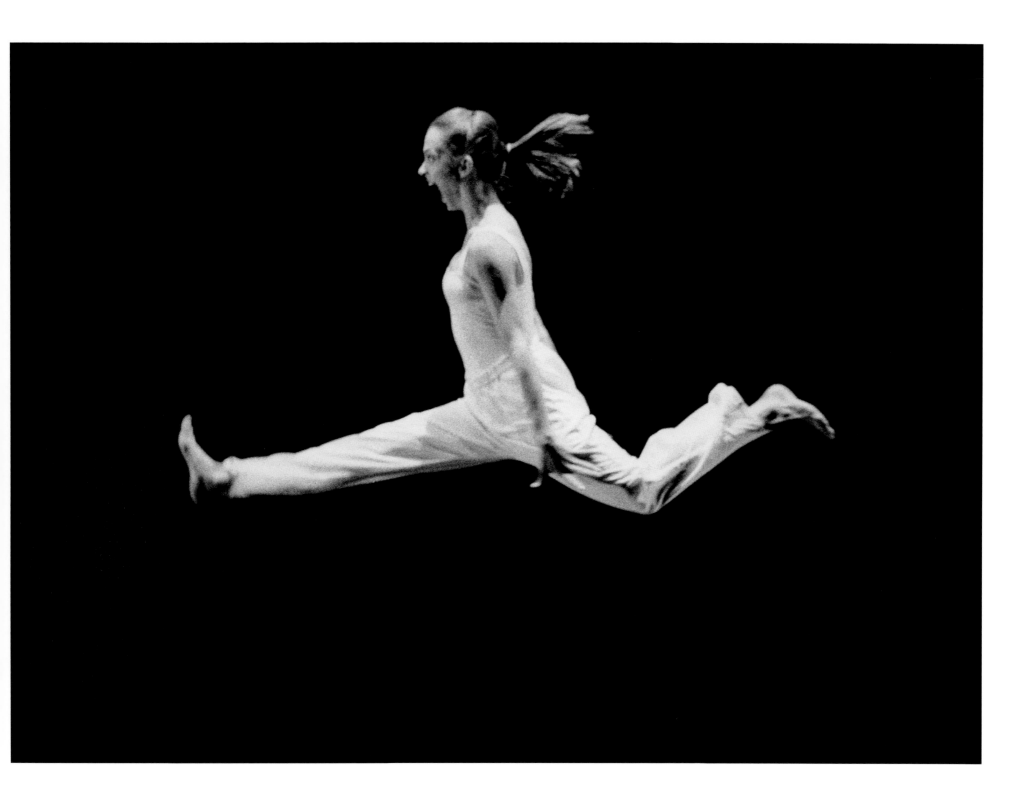

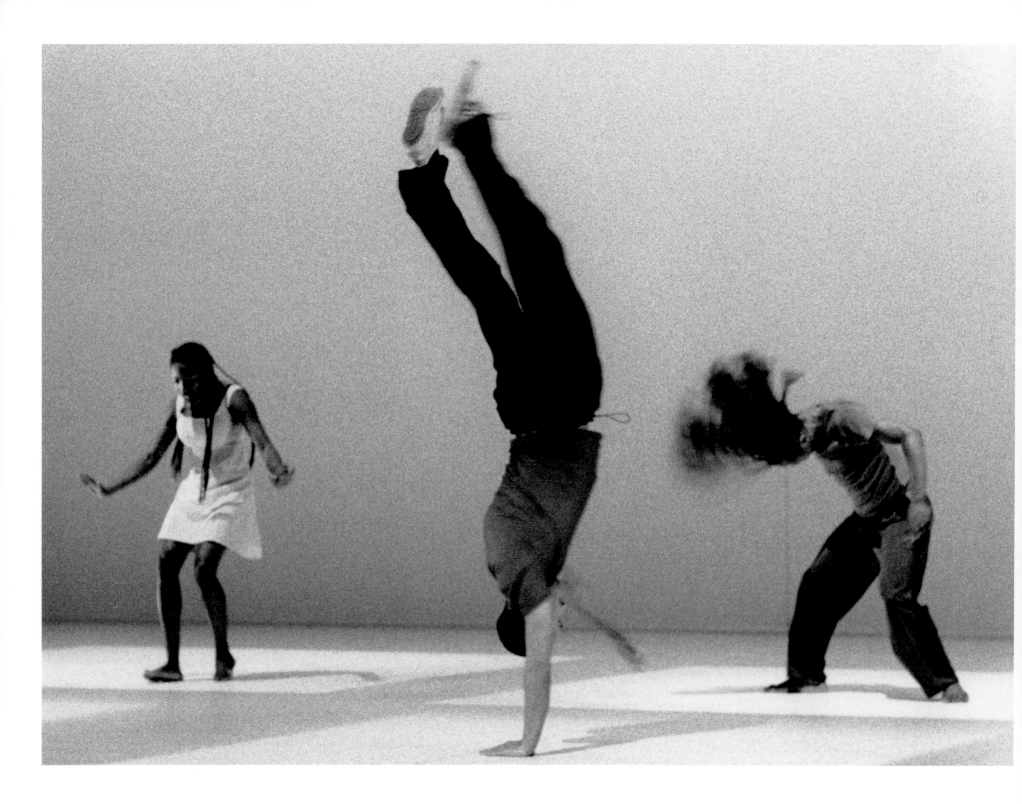

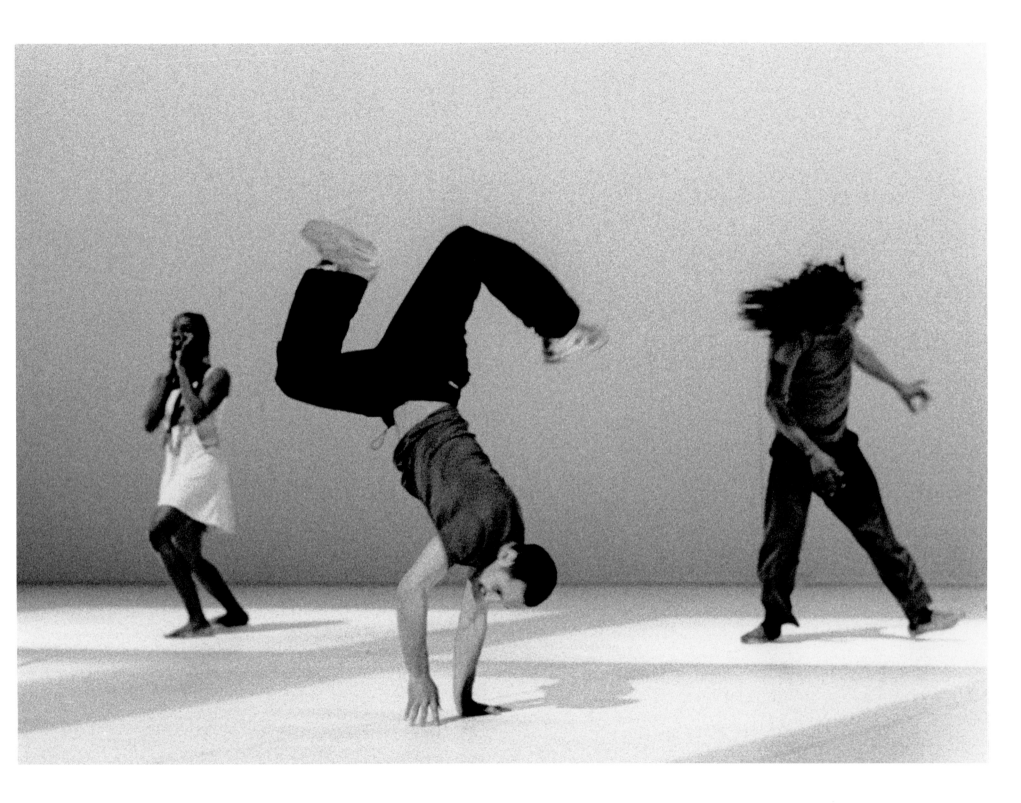

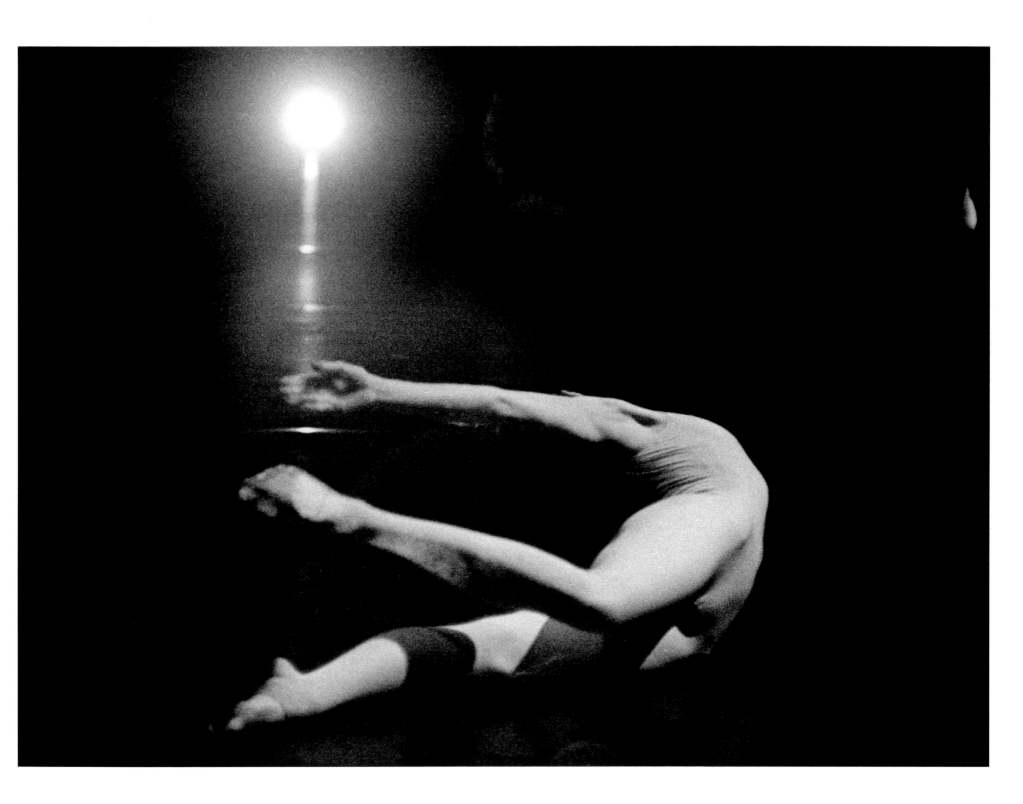

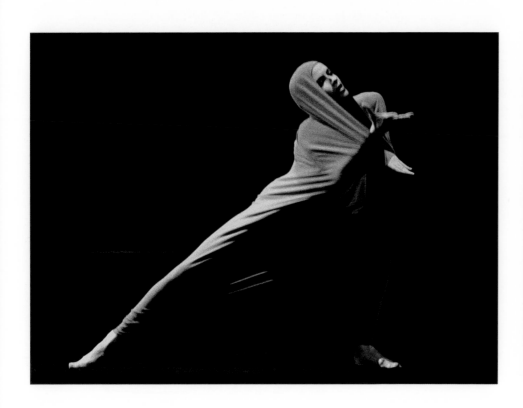
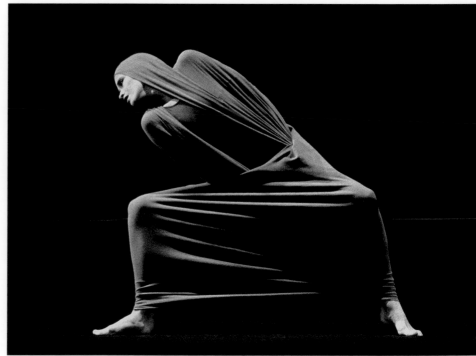

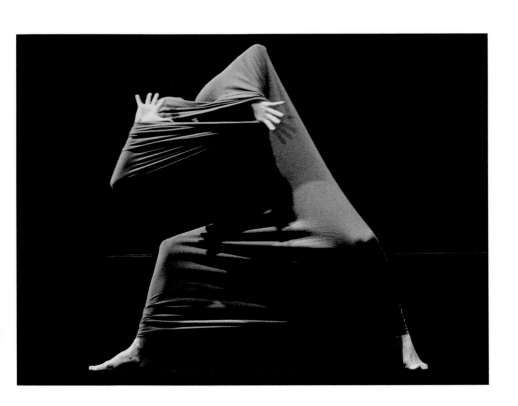

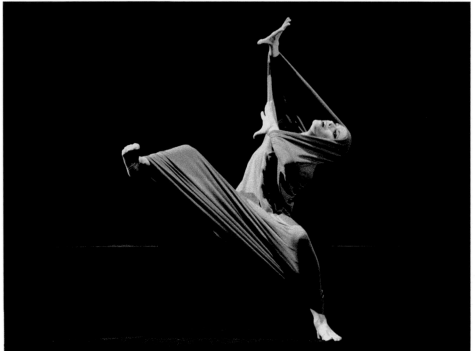

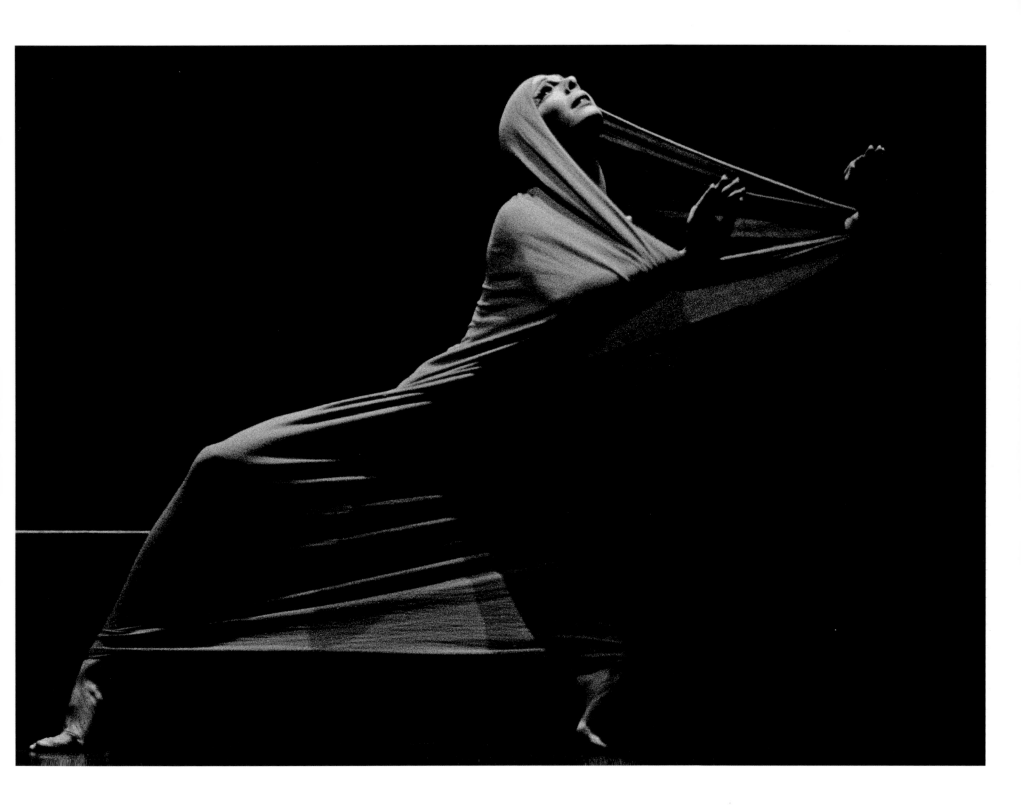

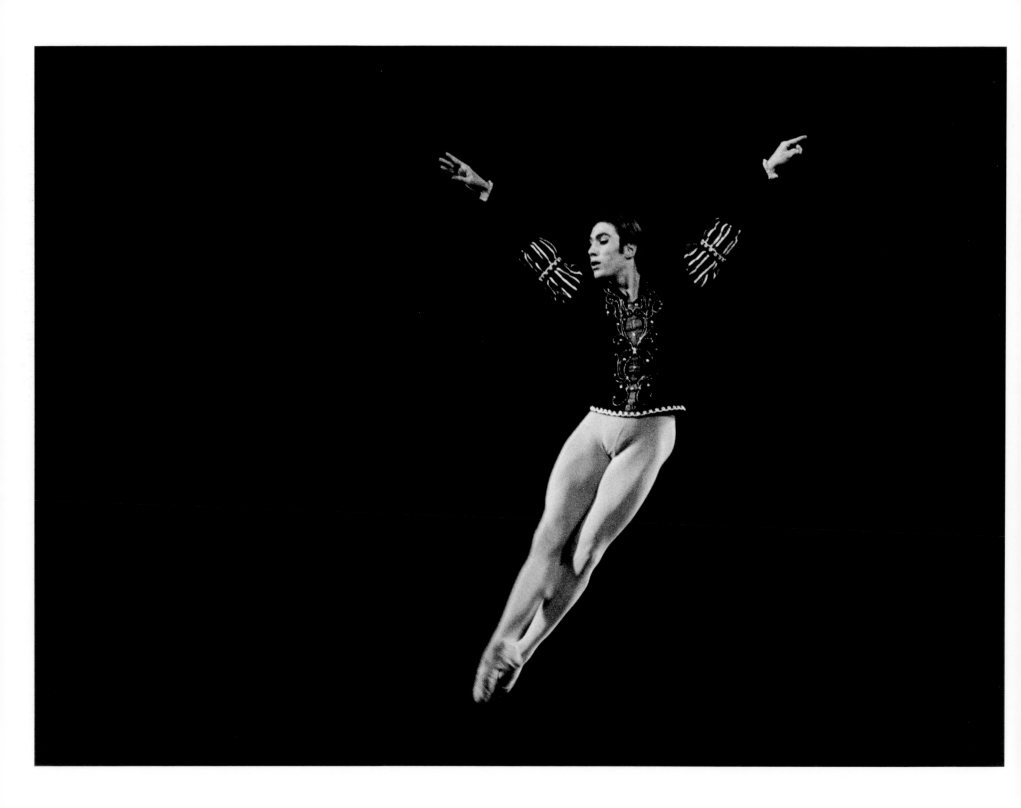

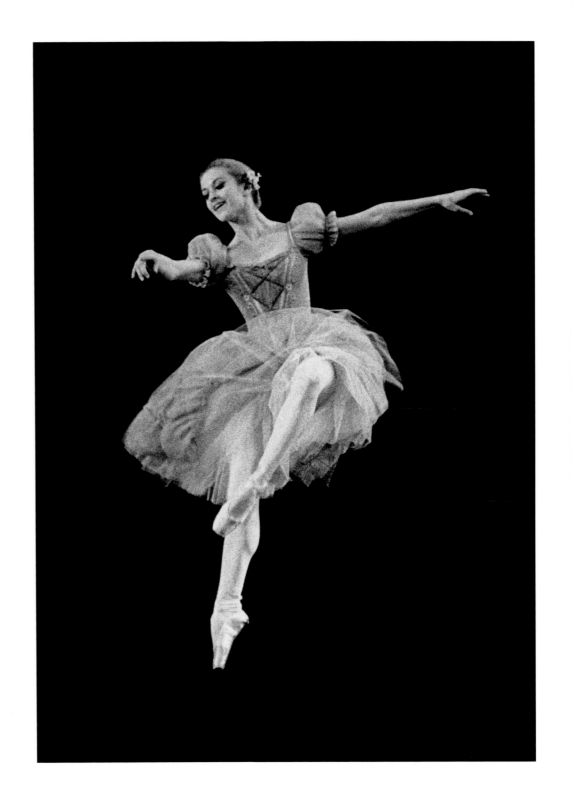

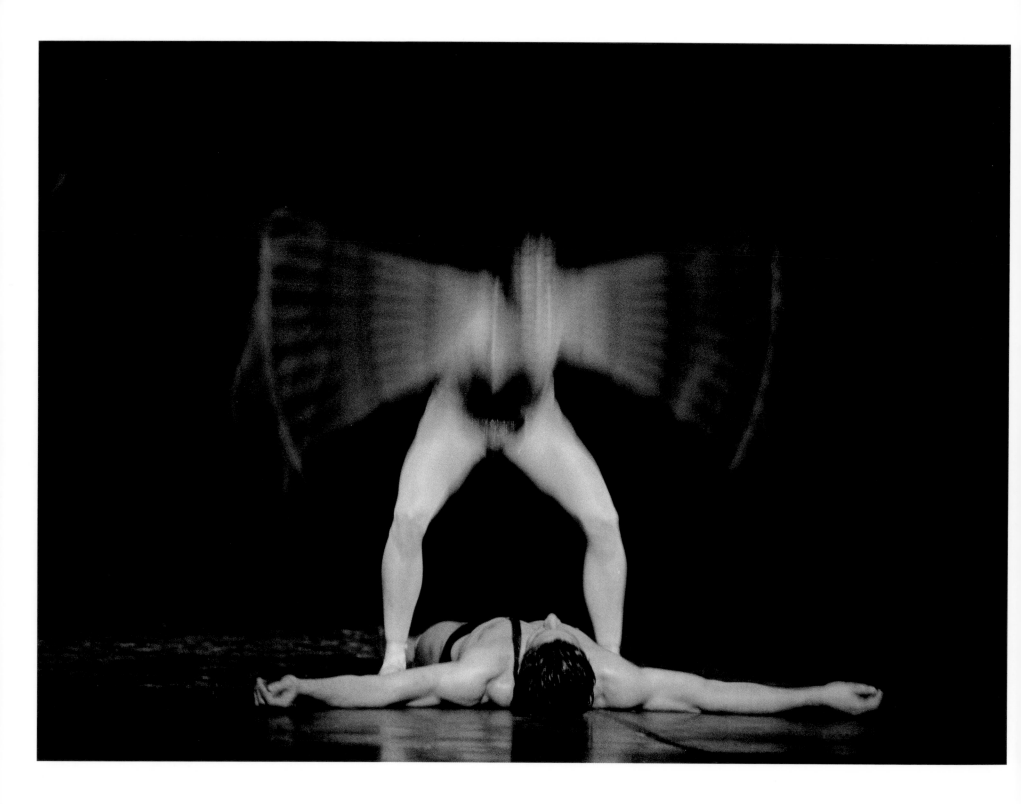

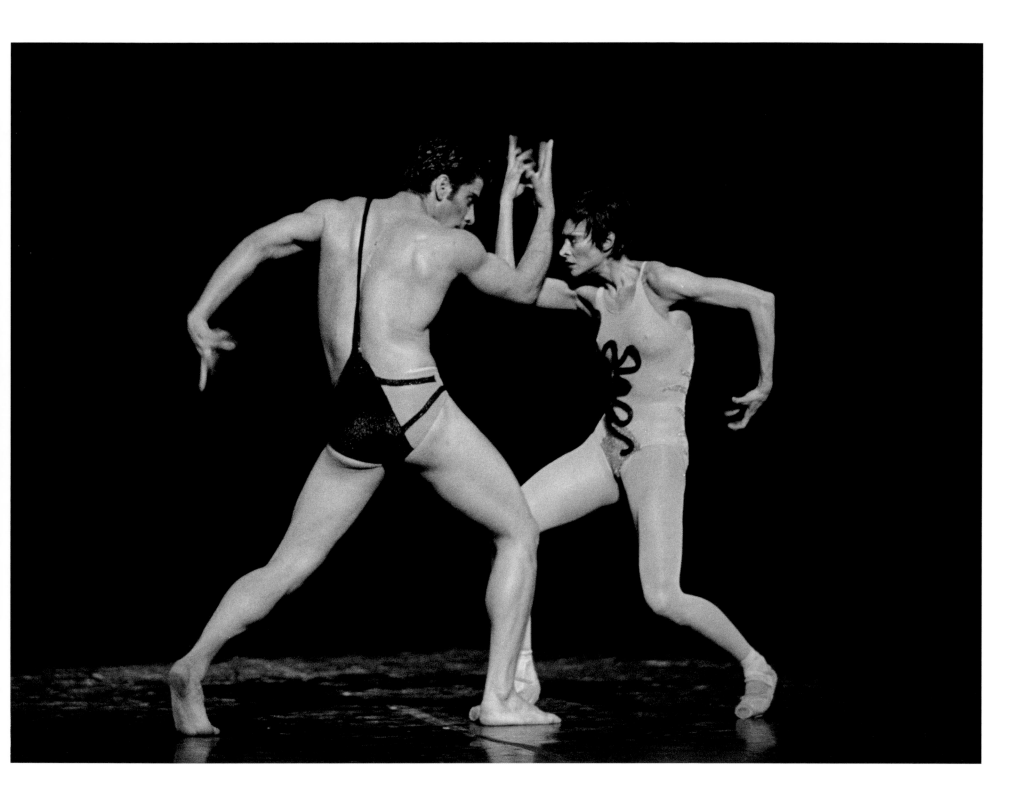

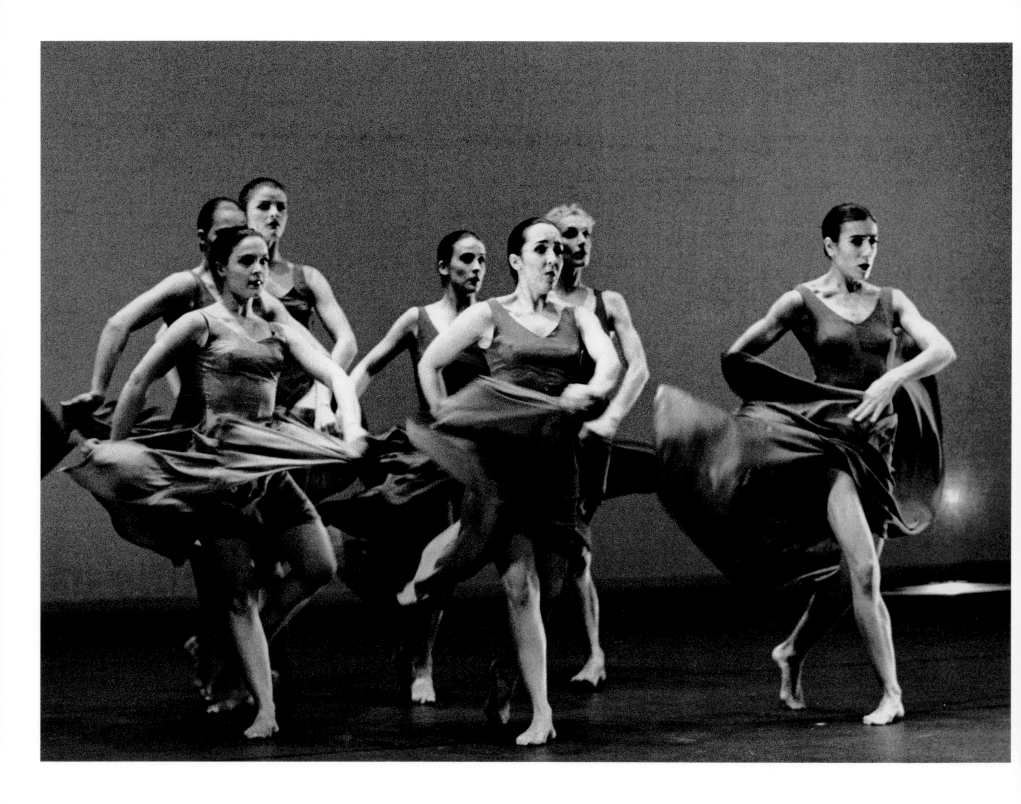

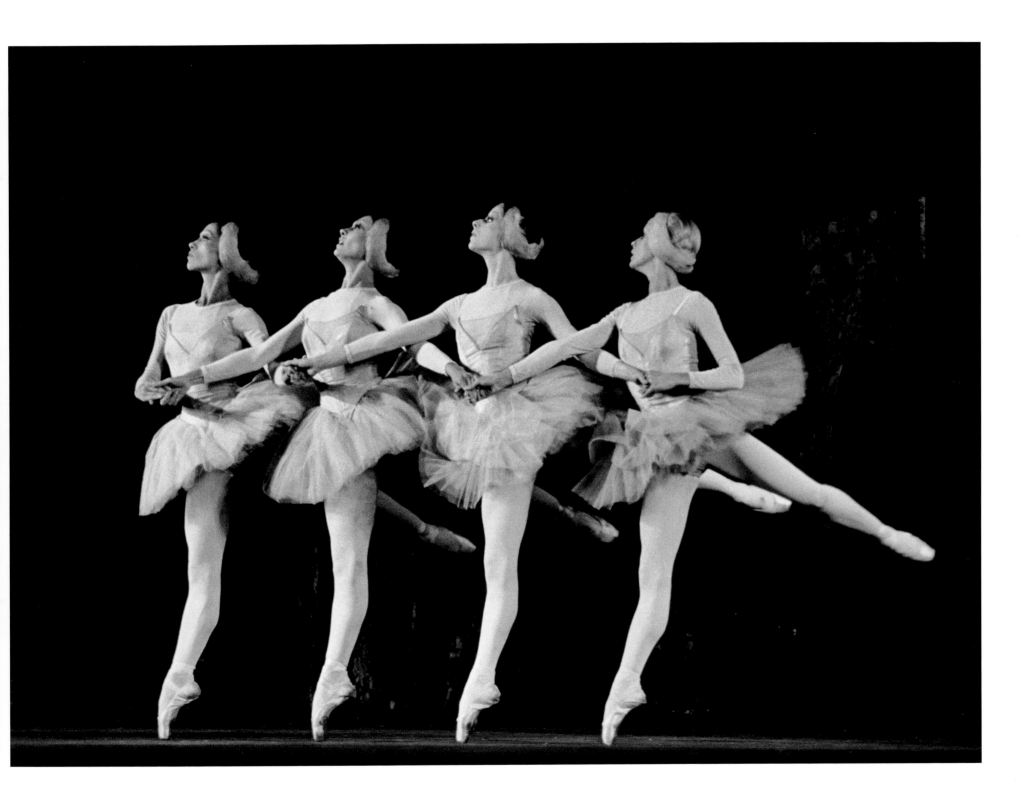

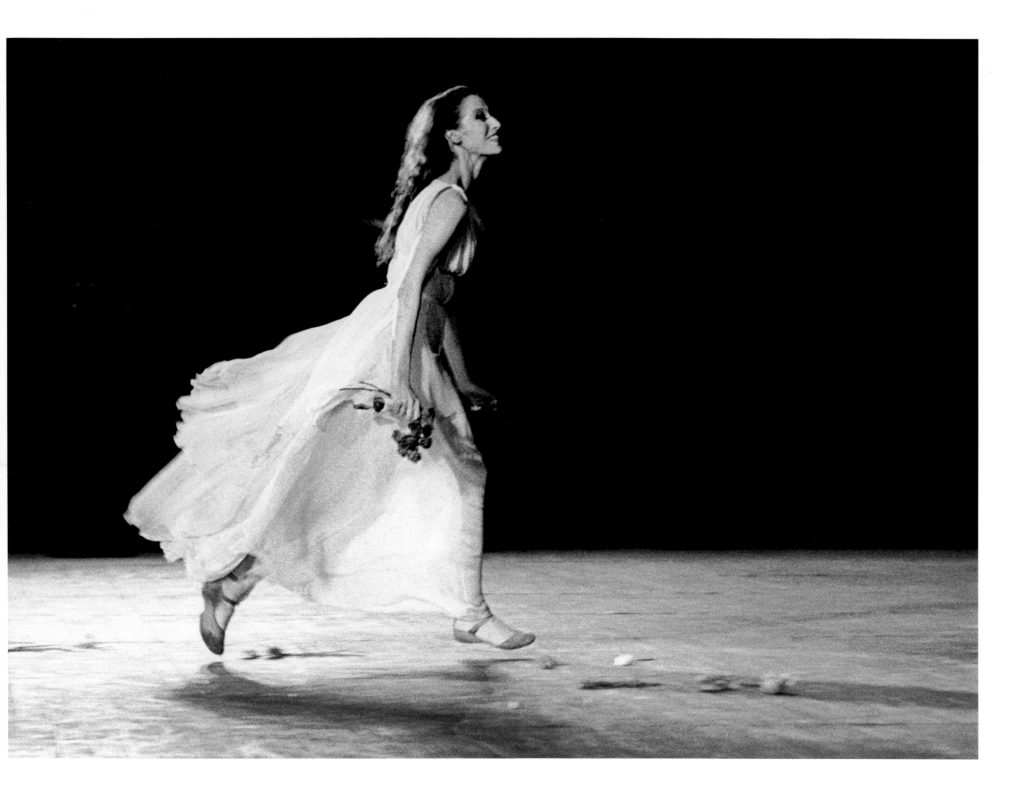